OUR CHRISTIAN SYMBOLS

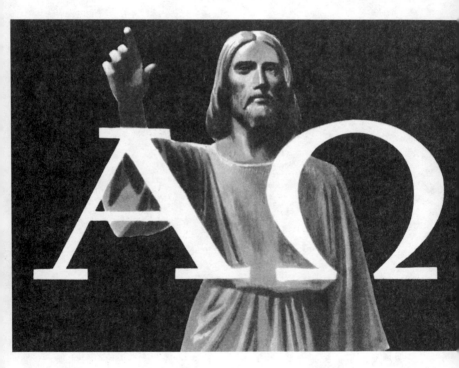

OUR CHRISTIAN SYMBOLS by FRIEDRICH REST

Illustrated by HAROLD MINTON

THE PILGRIM PRESS • NEW YORK

Second printing, December 1961
Third printing, January 1965
Fourth printing, October 1969
Fifth printing, June 1973
Sixth printing, November 1976
Seventh printing, July 1979
Eighth printing, September 1980
Ninth printing, June 1983

ISBN 0-8298-0099-9

Library of Congress Catalog Card Number: 53-9923

The Pilgrim Press
132 West 31 Street
New York, New York 10001

CONTENTS

INTRODUCTION

J ESUS used symbols again and again. He referred to himself as the Good Shepherd, the Door, the Light of the World, the True Vine. When he wanted to teach his disciples humble service he girded himself with a towel and washed their feet. To make vivid the opportunities for evangelism he said to his disciples, "Lift up your eyes, and see how the fields are already white for harvest" (John 4:35). His triumphant entry into Jerusalem on the back of an ass suggests that he was ready to announce his kingship. Many of his miracles and parables are filled with symbolism. The Christian Church throughout the world remembers the night when he instituted the blessed Sacrament, how he said, when he had taken bread and given thanks, "Take, eat; this is my body." In like manner he also took the cup.

Symbols are common in every walk of life. Every day we use symbols of friendship when we shake hands, nod or wave or smile to someone; likewise when we send greeting cards, flowers, or gifts. In the world of thought we constantly use words which stand for ideas and experiences. In our schools we use letters and numbers in order to grade pupils, and bells to signify that school is to begin again or that a class period is over. The business world could hardly get along without checks to represent money in the bank.

Despite the extensive use of symbols by our Lord and the common use of symbols in everyday life, some people do not care for symbols in church. In the days of Elizabeth and Cromwell there were people who went so far as to think they were working for the glory of God when they destroyed pipe organs, stained glass windows, and other works of art. The only justification for disliking symbols is fear of their becoming idols—ends in themselves rather than representations of something greater. There is no danger of idolatry when the meaning of a symbol is understood.

There are two great values in symbols: devotional and educational. We say that there is a devotional value in symbols because they help to remind us of the Christian faith; they create an atmosphere of worship and provide food for thought even before the prelude begins; they serve as means of expressing our faith when we plan symbols for a new church building, or a new interior decoration for the church, or meaningful decorations for printing or mimeographing.

Probably the greatest value of symbols is educational. It is surprisingly profitable and refreshing for adults as well as for children to approach the cardinal ideas of Christianity through church symbols. To cite only one example, an explanation of our belief in the Trinity is made easier and more interesting by referring to the symbols of the Holy Trinity.

In the classroom as well as in the sanctuary Christian leaders will find an interesting approach in symbolism for the difficult task of instructing others in the faith of our fathers. Symbols can be starting points, object lessons which remain for a long time, in introducing the great themes of our religion.

One afternoon a visitor on the campus of Eden Theological Seminary in Webster Groves, Missouri, raised a few questions with reference to wood carvings and other decorations in the chapel. The author, who was then a senior, had to admit that he was almost totally ignorant concerning church symbols. Since then he has found inspiration in the study of symbols. He hopes that the general reader will secure help in these pages for his understanding of popular Protestant symbols, and that church leaders will find both text and illustration an aid for class sessions, lectures, or sermons.

The one hundred original illustrations have been reproduced in a beautiful filmstrip showing the symbols in four colors.

The author wishes to thank Dr. Howard B. Kelsey for encouragement in organizing the material for publication. The author's wife, his brothers William, Karl, and Heinrich, and sister Louise, and Irvin Swan helped to improve parts of the manuscript. He is deeply grateful to the artist Harold Minton for the excellence and fine religious quality of the illustrations.

<div align="right">FRIEDRICH REST</div>

OUR CHRISTIAN SYMBOLS

✦ GOD THE FATHER ✦ ✦

THE HAND The hand, appearing in various forms, is probably the most outstanding symbol of God the Father. Of the many passages in the Old Testament which speak of the hand of God we quote only two: "Thy right hand, O Lord, glorious in power . . . " (Exod. 15:6); "Thy right hand is filled with victory" (Ps. 48:10).

1. The first pictures of the hand of God always showed it extending from a cloud. A reference was thus made, and is sometimes made today, to the glory of the Lord which abode upon Mount Sinai, which, the Bible tells us, was covered with a cloud for six days (Exod. 24:16). Sometimes artists symbolized God by simply picturing a cloud with rays of light coming out—indicating the dimness of our knowledge of God through the patriarchs and prophets of Old Testament times.

2. Early in Christian art, the hand alone extends downward from a cloud, but later a circle, symbol of eternity, surrounds the hand, which has the thumb and first two fingers extended. A three-rayed nimbus, sym-

THE HAND FROM A CLOUD

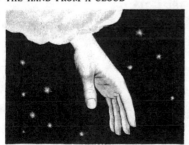

HAND OF GOD WITH CIRCLE

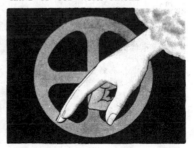

bol of Deity, completes the attractive symbol of benediction or blessing.

Before describing three other forms in which the hand of God appears, it may be helpful to note that the nimbus, consisting of light which surrounds the heads of sacred persons and symbols, is a sign of sanctity and light. When used with Deity symbols, the nimbus contains three rays of light which look something like three equally long arms of a cross. This type of nimbus, called triradiant or three-rayed, helps one to know that a symbol of God is meant.

3. A widely known symbol showing five tiny human beings in the hand, which is extended downward from a bright cloud, expresses the thought of being held in the hand of God (Ps. 139:10). The Book of Wisdom puts it this way: "The souls of the righteous are in the hand of God."

Two other widely used forms of the hand of God are the Latin and the Greek.

4. The Latin form shows the thumb and the first two fingers extended while the other two fingers are bent toward the heel of the hand. The three fingers refer to the grace of our Lord, the love of God, and the communion of the Holy Spirit.

5. The Greek form of the hand of God shows the forefinger extended upward. The longest and shortest fingers are bent downward in a semicircle. The thumb crosses the ring finger. Reading from right to left, the letters IC XC are formed; they are an abbreviation of the Greek name for Jesus Christ, an abbreviation explained more fully in the next chapter. The child of confirmation age takes delight in seeing how quickly he can form this symbol with his hand.

HUMAN BEINGS IN HAND OF GOD THE LATIN FORM

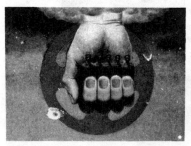 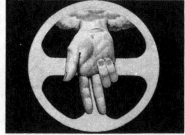

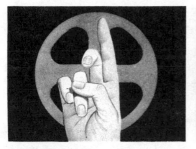

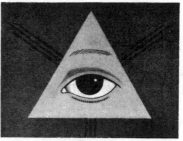

THE GREEK FORM THE ALL-SEEING EYE

THE ALL-SEEING EYE Another common symbol of God the
Father is the all-seeing eye. Usually pictured within a triangle above the altar, the all-seeing eye is a symbol of the Father's omniscience: "Behold, the eye of the Lord is on those who fear him" (Ps. 33:18).

THE CREATOR'S STAR While the hand of God or the all-seeing eye is generally used to symbolize God the Father, mention should also be made of the six-pointed star as a symbol of God the Creator. The joyful message that this star speaks to the imaginative Christian is beautifully phrased in the hymn written by Joseph Addison in 1712:

> The spacious firmament on high,
> With all the blue ethereal sky,
> And spangled heavens, a shining frame,
> Their great Original proclaim:

THE CREATOR'S STAR

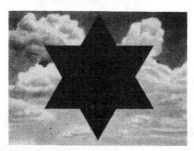

3 ·

The unwearied sun, from day to day,
Does his Creator's power display,
And publishes to every land
The work of an almighty hand.

Soon as the evening shades prevail,
The moon takes up the wondrous tale,
And nightly to the listening earth
Repeats the story of her birth;
Whilst all the stars that round her burn,
And all the planets in their turn,
Confirm the tidings as they roll,
And spread the truth from pole to pole.

What though in solemn silence all
Move round this dark terrestrial ball;
What though no real voice nor sound
Amidst their radiant orbs be found;
In reason's ear they all rejoice,
And utter forth a glorious voice,
Forever singing, as they shine,
"The hand that made us is divine."

✦ ✦ GOD THE SON ✦ ✦

SACRED MONOGRAMS There are many symbols of our Savior, including five sacred monograms; the first three monograms or abbreviations described below are quite popular in Protestant churches today.

1. The question might be asked, "Why does the Alpha and Omega appear so often on our altars and pulpit hangings?" Should someone say that the Alpha and Omega stand for the first and last letters of the Greek alphabet, he would be giving an incomplete answer. The Church is not interested generally in keeping certain portions of foreign languages before the laity. The Alpha and Omega stand for Jesus Christ, "the first and the last, the beginning and the end" (Rev. 22:13), "the same yesterday and today and for ever" (Heb. 13:8). The symbol is most clear when there is something to complete the visible connection between these letters and Jesus Christ.

2. Another popular symbol is IHS. Six interpretations are given to the letters IHS or IHC; the first is the one preferred, since it is historically correct, but the others are not to be ignored; they have several centuries of tradition behind them.

(a) The first explanation is that the letters are formed from the Greek word (IHCOYC) for Jesus. As knowledge of Greek became rare, the Greek C was changed to a Latin S, so the abbreviation was often IHS instead of IHC.

(b) The Latin words *Iesus Hominum Salvator* (Jesus, Savior of Men) are often used to explain the symbol.

(c) A popular interpretation is the German *Jesus, Heiland, Seligmacher* (Jesus, Lord, Savior).

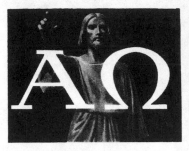 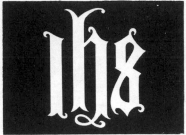

ALPHA AND OMEGA IHS

(d) The English sometimes say IHS means "I (Christ) Have Suffered."

(e) Others find in the symbol this meaning: "In this sign (the cross) shalt thou conquer." The Latin reference is *In hoc signo,* but the symbol of the cross and the word for "shalt thou conquer" (*vinces*) are often missing.

(f) The following interpretation is better than the fifth one mentioned, especially when a cross is combined with the IHS: The letters are said to signify *In hac salus* (In this [cross] is salvation).

Broadly speaking, we may conclude that all of these interpretations are acceptable, for they have become practically traditional. When the cross is not combined with the IHS, however, it is best not to explain that they mean "In this sign (the cross) shalt thou conquer" or "In this (cross) is salvation." It is perhaps best to say simply, "IHS means Jesus."

The symbol IHC or IHS appears at the very center of the altar cross in many churches. Thus we are reminded that the central teaching of the cross is that God's suffering love for humanity is revealed in Jesus Christ on the cross.

3. The Chi Rho symbol, an ancient monogram of Christ, appears often on altars, book marks, antependia, and stoles. Where did it come from? What does it mean?

The most usual form consists of the P within the X. The monogram has been in Christian use for at least 1600 years. Constantine the Great had the monogram of Christ placed on the shields of his soldiers.

The symbol ☧ is derived from the first two letters of the Greek word XPICTOC (pronounced *Christos*). The letters abbreviate the name of Christ.

Closely related is a symbol in which the *P* is replaced with an *I*. *I* is the first letter of the Greek word IHCOYC (pronounced *Yasous*). The *X*, as we have indicated, is the first letter of the Greek word for Christ. The *I* is placed within the *X* to form an abbreviation for Jesus Christ. This ancient type of Christogram is rarely found in churches today.

A few more facts should be noted about abbreviations in this connection. The abbreviation "Xmas" stands for Christmas; the "X" is here plainly an abbreviation for the word Christ. Sometimes the letter *t* is added to *X* (Xt) to stand for Christ.

The letters INRI, which we find sometimes on Holy Communion wafers, refer to the title, "Jesus of Nazareth, the King of the Jews" (John 19:19), which in Latin is *Iesus Nazarenus Rex Iudaeorum.*

Occasionally we find another abbreviation in Protestant churches. A cross divides a section into four parts, and in each part are placed two letters. In the upper left corner are the letters IC, which abbreviate the name Jesus. In the upper right corner are the letters XC, which stand for the name of Christ. In the left corner below the horizontal bar of the cross are the letters NI, and in the lower right corner, KA. The letters IC XC NIKA stand for "Jesus Christ conquers." Since they are grouped around the cross one may add, "by the cross." Sometimes, in other arrange ments for decoration, the letter *N* is used to stand for the word *nika*.

THE LAMB OF GOD Out of the Hebrew sacrificial system, Christian application is made of the lamb as the symbol of Jesus Christ. John the Baptist said of him, "Behold the Lamb of God, who takes away the sin of the world" (John 1:29). Similar reference is made in the book of Revelation, and subsequently in the great hymns and prayers of the Church. Quite often the symbol of the lamb is

THE CHI RHO SYMBOL

THE IX SYMBOL

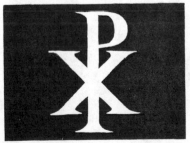

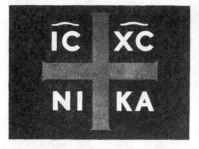 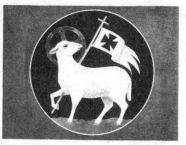

JESUS CHRIST CONQUERS THE LAMB OF GOD

found in one form or another on communion ware and liturgical hangings.

Sometimes the lamb carries a resurrection banner, or a white pennant with a red cross on a cruciform standard. The white pennant represents the body of Christ, which is attached to the cruciform staff, representing the cross on which the Lamb of God died and through which the risen Christ saves the world. When the lamb is depicted as lying down, reference is made to the suffering and burden-bearing Christ, on whom the Lord laid "the iniquity of us all" (Isa. 53:6). When the lamb is standing, suggestion is given that the Lamb of God is triumphant, risen.

The following hymns have made good use of the symbol: "O Lamb of God Who, Bleeding," "Crown Him With Many Crowns," "My Faith Looks Up to Thee," and "O Lamb of God, Still Keep Me."

THE CRUCIFIX Not technically referred to as a symbol, the crucifix is a representation or a figure of Christ suspended on his cross. Christ is pictured in two different forms on the cross. The one represents him as living and reigning from the cross, clothed as Prophet, Priest, and King, with a three-rayed nimbus in back of his head indicating his deity. There is a renewed interest in this type of crucifix, due to a wholesome desire to picture the living Christ.

On the other hand Jesus Christ is represented as the suffering servant, with a crown of thorns and bended knees indicating pain. This portrayal is consistent with one important phase of New Testament realism. St. Paul wrote, "We preach Christ crucified" (I Cor. 1:23).

THE FISH In the days when it was dangerous to be a Christian, the followers of Jesus resorted to secret signs and symbols to keep from exposing themselves unnecessarily to the foes of Christianity.

For example, a man sometimes drew the picture of a fish in the sand while talking with another. If the figure was recognized to signify more than an unconscious movement during the course of a conversation, the two would identify each other in the Christian faith.

During the days when Christians had to worship in secret, visiting Christians could find their way to the worship center in the long underground passageways by simply looking at the fish on the wall pointing in the direction in which they were to go.

The strange symbol of the fish has an intricate background. The Greek word for fish (pronounced *ichthus*) is formed by using the first letter of each of the words in Greek (pronounced, but not spelled, *Yasous Christos Theou Hyos Soter*), which stand for "Jesus Christ, Son of God, Savior." It was precisely because the symbol was difficult to understand that it was precious. It was a protection from non-Christians.

While the single fish represents the Savior, several fishes represent faithful Christians. In Matt. 4:19 the beginnings of the development of the symbol can be seen: "And he said to them, 'Follow me, and I will make you fishers of men.'"

A conventionalized form of the fish is the *vesica piscis,* Latin for the bladder of a fish. It is a pointed oval figure.

The fish as a symbol does not appear often today. But whenever we see it, we think of an heroic time when Christians underwent persecutions and trials for their faith and succeeded in spreading the gospel despite many obstacles.

OTHER SYMBOLS To give a complete description of all the symbols that have been associated with God the Son would require many pages. We present only a few:

THE LIVING AND REIGNING CHRIST THE FISH

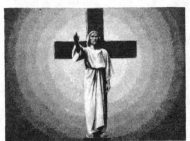 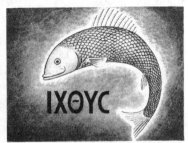

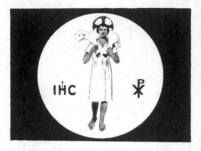

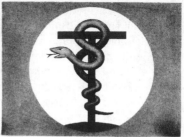

THE GOOD SHEPHERD THE BRAZEN SERPENT ON A CROSS

1. The Good Shepherd is a symbol of Jesus Christ (John 10:11).

2. The use of the vine has its biblical background in John 15:1—"I am the true vine." This symbol, with branches representing his followers, is often seen in wood carvings and paintings.

3. The door is also symbolic of our Savior, since he said, "I am the door" (John 10:9).

4. The brazen serpent on a cross refers to John 3:14, where we read, "As Moses lifted up the serpent in the wilderness, so must the Son of man be lifted up."

5. The symbolism of the pelican-in-her-piety rests upon a story often given, that the pelican tears open her breast and feeds her young with her own life blood in times of famine. It is a symbol of Jesus Christ and his atonement on the cross.

6. When an ox is pictured without wings, the reference is Matt. 11:30, "For my yoke is easy, and my burden is light." It is a symbol of Jesus Christ who is able to carry many burdens. With wings, the ox is a symbol of St. Luke.

7. The sun as a symbol of Jesus Christ, while seldom portrayed in churches today, is so rich in suggestion that we may include it here. The prophet Malachi spoke of a time when the "sun of righteousness" shall "rise, with healing in its wings" (Mal. 4:2). Both the sun and the Son bring light and life into the world. When Julian the apostate tried to revive sun worship in the fourth century, he found the worship of the Son of God an insurmountable obstacle.

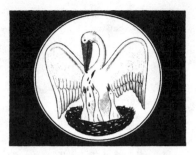

THE PELICAN-IN-HER-PIETY

8. The candlesticks upon our altars remind us of the words, "I am the light of the world" (John 8:12). As we shall point out later, the two candlesticks also represent the two natures of Jesus Christ—the human and the divine.

9. The crown represents Jesus as Lord and King. It refers also to the reward of a faithful Christian life, as suggested in 1 Peter 5:4—"And when the chief Shepherd is manifested you will obtain the unfading crown of glory." Matthew Bridges has put into forceful words the Christian's recognition of Jesus as King:

> Crown him with many crowns,
> The Lamb upon his throne;
> Hark! how the heavenly anthem drowns
> All music but its own:
> Awake, my soul, and sing
> Of him who died for thee,
> And hail him as thy matchless King
> Through all eternity.
>
> Crown him the Lord of love;
> Behold his hands and side,
> Rich wounds, yet visible above,
> In beauty glorified:
> No angel in the sky
> Can fully bear that sight,
> But downward bends his burning eye
> At mysteries so bright.
>
> Crown him the Lord of peace;
> Whose power a scepter sways
> From pole to pole, that wars may cease,

Absorbed in prayer and praise:
His reign shall know no end;
And round his pierced feet
Fair flowers of Paradise extend
Their fragrance ever sweet.

Crown him the Lord of years,
The Potentate of time;
Creator of the rolling spheres,
Ineffably sublime:
All hail, Redeemer, hail!
For thou hast died for me:
Thy praise shall never, never fail
Throughout eternity.

GOD THE HOLY SPIRIT +

THE DESCENDING DOVE The most usual symbol of the Holy
 Spirit is the descending dove, with a
three-rayed nimbus around its head. In the story of Jesus' baptism we
read that the Holy Spirit descended "like a dove" (Mark 1:10). Sometimes
an artist will show the dove surrounded by stars, as if coming down from
the starry heavens. Other uses of the dove as a symbol will be treated in
Chapter 17.

OTHER SYMBOLS Occasionally one will see a flame, or seven
 flames, representing the Holy Spirit on the Day
of Pentecost when "tongues as of fire" rested upon the followers of Christ,
and "they were all filled with the Holy Spirit" (Acts 2:3-4).
 The seven gifts of the Holy Spirit, pictured variously in symbolism, are
taken also to symbolize the Holy Spirit itself.

GIFTS OF THE HOLY SPIRIT In religious art the Savior is some-
 times surrounded with seven
doves, which represent the gifts of the Holy Spirit: wisdom, understand-
ing, counsel, might, knowledge, piety, and fear of the Lord. Six of these
traditional gifts are mentioned in Isaiah 11:2. Piety was added later. The
list from Revelation 5:12 consists of power, wealth, wisdom, might, honor,
glory, and blessing.
 Sometimes each dove holds a scroll in her beak with a virtue inscribed
in Latin upon it. The seven gifts of the Holy Spirit are sometimes por-
trayed by a seven-fold flame, and again by a seven-pointed star with the
initial of each gift within each point of the star. When the points of a nine-
pointed star contain the initial or name of a gift, Gal. 5:22-23 must be

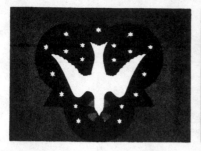
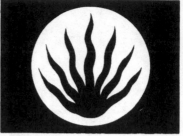

THE DESCENDING DOVE THE SEVEN FLAMES

consulted, as this reference lists love, joy, peace, longsuffering, gentleness, goodness, faith, meekness, and temperance as the fruits of the Spirit.

> Spirit of God, descend upon my heart;
> Wean it from earth, through all its pulses move;
> Stoop to my weakness, mighty as thou art,
> And make me love thee as I ought to love.
>
> Teach me to love thee as thine angels love,
> One holy passion filling all my frame;
> The baptism of the heaven-descended Dove,
> My heart an altar, and thy love the flame.

✛ THE HOLY TRINITY ✛

THE PRIMARY difficulty in thinking of the Holy Trinity often lies in the word "person." We sing, "God in three Persons, blessed Trinity." The idea may occur to many as they sing in services of divine worship that there are three *individuals* involved. The three "Persons" in the Godhead are not three individuals. To understand this it is necessary to recall the way in which ancient people used the word person.

In ancient Italy and Greece, actors on the stage put a mask on their faces to help characterize the person they were representing. This mask was called *persona,* from which our word person is derived. When we use the word in relation to the Trinity, we revert to the ancient usage; therefore, the "Persons" of the Godhead are representations, pictures, or roles of God in action. God is seen in the role of "Maker of heaven and earth"; in Jesus Christ he is seen as Redeemer, or Savior; in the human heart he is experienced as Enlightener and Sanctifier. These words broadly classify God in three main roles, three aspects, three functions. The reference to the *persona,* or mask, is easily seen when we recall that in ancient times a head was pictured with three faces to represent the Trinity.

THE TRIANGLE The triangle is one of the most popular symbols of the Holy Trinity. Each side of the triangle represents a "Person" of the Godhead. One line represents the Father, another the Son, and the third the Holy Spirit. Together the lines form one triangle, usually equilateral. Sometimes a triangle is formed with three fishes. When two triangles are interwoven, the significance of the single triangle is doubly emphasized. At the same time the intersected triangles form a six-pointed star, which is a symbol of the creation of the world.

THE SHIELD OF THE TRINITY Another geometrical symbol of the Holy Trinity is more complicated. To visualize it, picture a triangle with the lines converging to a single point at the bottom. At the top of the left line is a circle enclosing the word *Pater* for Father; the end of the right line has a circle enclosing the word *Filius* for Son; at the bottom of the triangle are the words *Spiritus Sanctus* for Holy Spirit. In the center is the word *Deus* for God.

The unity of the Godhead is pictured by using the word *est* on each line starting from the corners and leading to *Deus*. Thus one may read: "The Father is God; the Son is God; the Holy Spirit is God."

The separate phases of the Godhead are clearly pictured by the words *non est* written on other lines running from the Father to the Son to the Holy Spirit to the Father. Translating this part of the symbol we read: "The Father is not the Son; the Son is not the Holy Spirit; the Holy Spirit is not the Father."

THE TRIQUETRA The triquetra, a design consisting of three equal arcs, is also used as a symbol of the Holy Trinity. Its beauty as an architectural design may be seen on some church buildings. Its richness may be noted in that half the length of each pair of arcs forms a *vesica piscis* (bladder of a fish).

THE INTERWOVEN CIRCLES The three interwoven, or interlaced, circles constitute another popular symbol of the Trinity. Each circle represents one of the Persons in the Trinity. The circle has no apparent beginning or ending, signifying the eternal nature of each Person in the Godhead. Usually the three circles are interlaced or intertwined, thus forming one design which symbolizes the

THE TRIANGLE

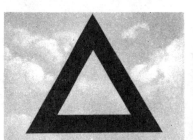

THE SHIELD OF THE TRINITY

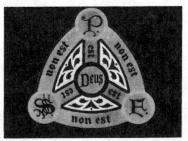

· 16

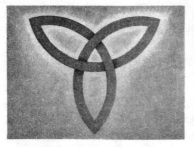

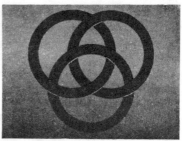

THE TRIQUETRA THE INTERWOVEN CIRCLES

unity of the eternal God as Father, Son, and Holy Spirit. God the Father is the Creator, revealed by Jesus Christ, and operating in humanity as Holy Spirit. Other variations are formed in artistic design, as when, for instance, the circle is combined with the triangle.

THE NUMBER THREE There is a memorable little legend about St. Patrick and the Holy Trinity. One version of the legend states that he was near a meadow one day when Irish chieftains asked for an explanation of the Trinity. St. Patrick saw a shamrock, a yellow flower with three leaves, plucked it, and said in effect: "God is like this flower; this flower has three petals, and the three petals form this shamrock. So God consists of three Persons, and yet is one God."

Whether the story is historically true or not, the shamrock is used advantageously to explain the Trinity. The same use is made of the trefoil, a three-leafed herb which is ornamentally foliated in slightly different form. For the sake of clarity and beauty, a triangle or circle is often

TREFOIL, FLEUR-DE-LIS, SHAMROCK

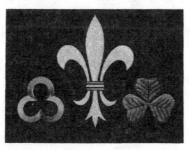

added. The *fleur-de-lis* with its three divisions is a widely used symbol of the Trinity, despite the fact that it is also symbolic of the Virgin Mary.

Another symbol of the Trinity should be mentioned—candelabra with three candles. A fine shade of thought is suggested by the three candles above the stem which holds the candles aloft. The doctrine of the three Persons is in complete harmony with the idea of the unity of the one God.

Finally a word may be written about the adaptation of the number three to decorations in churches. Quite often three panels will be found on an altar and a reredos. Where there is a reference to the number three, generally speaking, the Holy Trinity is symbolized.

+ + + THE CROSS + + +

OF ALL Christian symbols, the cross is the most universally accepted. More than four hundred various shapes of the cross are in existence. Twenty-four of the most common forms are here presented.

1. A cross shaped like the Greek letter T, called the *Tau,* Old Testament, Advent, or Saint Anthony's cross, came to be used by early Christians instead of more obvious forms of the cross because they feared non-Christians who might not be sympathetic to participants in what was then an illegal movement. According to tradition, the blood on the Israelites' door-posts to save the first born formed this type of cross. It is also said to be the type of cross on which Moses lifted the brazen serpent, and is sometimes called an Anticipatory Cross (Num. 21:8-9; John 3:14).

2. The Greek cross has four arms of equal length. The Red Cross organization makes abundant use of this form of the cross which has been used for centuries in Christian art. It is especially adaptable in ornamentation. When five Greek crosses appear on the top of an altar, under the fair linen, reference is made to the five wounds of our Lord's crucifixion.

THE TAU CROSS

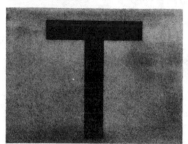

THE GREEK CROSS

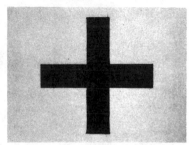

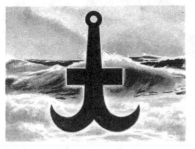

THE ANCHOR CROSS

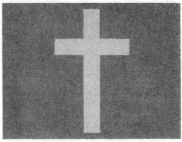

THE LATIN CROSS

3. When the top part of an anchor is in the shape of a cross it is called an Anchor Cross, a symbol of Jesus Christ, our sure Anchor. This cross is carried over from the days of persecution before Constantine, when Christians were able to see Christian hope in the anchor, while non-Christians saw nothing but an anchor. An anchor is a symbol of a hope "sure and steadfast" (Heb. 6:19).

Willard Sperry tells of a rural church in Maine where there is a painting of an anchor on the wall in back of the pulpit. Most of the people who worship in this church are connected with the trade of fishing and know the dangers of the sea from experience. The anchor is especially fitting to these folk because it speaks of hope and salvation in the midst of howling winds on a perilous sea. Our Lord, who saved Peter from drowning and who answers the prayers of the modern man as well, is the source of their hope.

4. The most popular form of all crosses is the Latin Cross, the form on which it is said our Lord was crucified. The Latin and the Greek forms

THE CALVARY CROSS ST. ANDREW'S CROSS

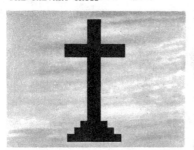

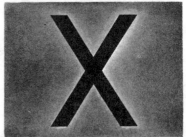

of the cross are the oldest Christian forms, and at the same time most basic in design, so that infinite variations are made from them.

5. When the Latin cross stands on three steps, which signify faith, hope, and love (1 Cor. 13:13), it is called the Calvary, or Graded, Cross. The Calvary Cross is symbolic of finished redemption, of Christ risen from the dead and reigning from the throne in heaven.

Occasionally someone will express the thought that the figure of Christ, the crucifix, does not belong on the altar in Protestant churches. A Protestant altar may have either a cross or a crucifix on it. Many Protestant, as well as Roman Catholic, churches have a crucifix, which is symbolic of our Lord's passion and atonement. It would seem to many to be as proper to have the crucifix on the altar as to have it in the imagination, as when we sing:

> Upon that cross of Jesus mine eyes at times can see
> The very dying form of One who suffered there for me;
> And from my smitten heart with tears, two wonders I confess,
> The wonders of his glorious love and my own worthlessness.

6. Saint Andrew's Cross came into use during the Middle Ages. It is also the national cross of Scotland. Other names for this cross are Cross Saltire or *Crux Decussata*—from the Latin *decusso,* meaning to divide cross-wise in the shape of the letter X.

7. The Jerusalem Cross, also known as the Five-Fold Cross and the Crusader's Cross, is composed of four Tau crosses which meet in the center. Generally four small crosses appear in the four corners.

To understand the symbolism of this cross three developments should be traced: (a) Originally known as the Five-Fold Cross, to represent the

JERUSALEM CROSS

THE MALTESE CROSS

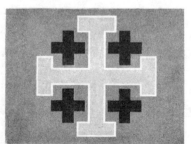
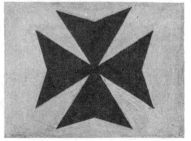

five wounds of our Lord's crucifixion, the Jerusalem Cross was the coat of arms of the first ruler of the Latin Kingdom of Jerusalem. (b) Later the cross was used extensively by the Crusaders, and the Five-Fold Cross was said to be symbolic of Great Britain, France, Germany, Italy, and Spain, as well as the five wounds. (c) Sometimes the four small crosses indicate the four corners of the earth to which missionaries of the cross have carried the gospel since the days of the original church in Jerusalem— represented by the large cross. The Old Testament prophecy (represented by the Tau crosses) was fulfilled on a hill near the city of Jerusalem.

8. The Maltese Cross has four arms of equal length, but each arm becomes progressively broader as it leaves the center in slanting, rather than curved, lines. There are two points at the end of each arm, eight in all, representing the beatitudes (Matt. 5:3-10). The most beautiful form shows the outer edges of each of the four spearheads in the Maltese Cross in a V shape, accentuating the eight points; this is sometimes found on pulpit or lectern hangings and interior decorations. The Maltese Cross is also an emblem of John the Baptist and of the Knights of St. John.

9. The Pointed Cross, known also as the Cross of Agony, the Cross of Suffering, Cross Urdée, Passion Cross, and Cross Champain, is symbolic of our Lord's suffering. When it is pictured rising out of a chalice, it represents our Lord's agony in the Garden of Gethsemane: "Let this cup pass from me" (Matt. 26:39).

10. The Cross Fleury (also spelled Fleurie) is a form having four arms of equal or unequal length, with pointed petal-like ends.

11. A cross with infinite variations is the Cross Patée. The arms curve outward from the center, and are straight or curved on the outer edges.

THE CROSS OF SUFFERING

THE CROSS FLEURY

THE CROSS PATÉE THE CELTIC CROSS

Sometimes confused with the Maltese Cross, the Cross Patée is distinguished largely by the graceful curves of the lines which come out from the center.

12. The Celtic Cross, sometimes called the Irish Cross, Cross of Iona, or Wheel Cross, has a circle signifying eternity around the middle part of the cross. This type of cross is often seen on covers of hymnals and other publications, on tombstones in cemeteries, on church steeples, altars, and church doors.

13. The Budded Cross, known also as the Cross Botonée, is a very beautiful cross often used on top of the Christian flag, and may be of either Latin or Greek type, with trefoil ends.

14. A cross often used in connection with printing and decorations for Easter is the Easter Cross, consisting of a Latin Cross with either rays of light shining as from the rising sun or Easter lilies surrounding it. The cross with rays of light may also be called the Cross in Glory.

THE BUDDED CROSS THE EASTER CROSS

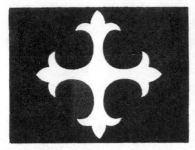

THE CROSS PATONCE THE CROSS FLEUR-DE-LIS

15. Another beautiful form of the cross is the Cross Patonce, which looks something like the Cross Fleury except that the arms gradually and gracefully curve out toward the three petals.

16. The Cross Fleur-de-lis consists of a *fleur-de-lis* at each end of large arms.

17. The Trinity Cross is similar but much more beautiful and intricate. Three *fleurs-de-lis* at each end of large arms appear on this design. The decorator and needle specialist can do a great deal with this form.

18. The Cross Crosslet, consisting of four Latin crosses with their lower arms joined in the center, is suggestive of the spread of the Christian faith to the four corners of the earth.

19. The symbol of the Cross and Crown stands for a reward to those who are faithful unto death (Rev. 2:10). Palm branches, referring to Jesus' triumphal entry (Matt. 21:8), and therefore symbolic of victory,

THE TRINITY CROSS THE CROSS CROSSLET

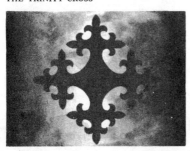
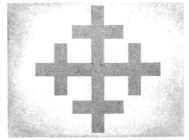

CROSS AND CROWN

CROSS OF TRIUMPH

sometimes surround the symbol. Triumph over death is promised to those who are faithful. When the crown is one of thorns around a slender cross, the Cross and Crown is then a passion symbol.

20. The Cross of Triumph, also known as the Cross of Victory, the Cross of Conquest, is composed of a Latin Cross on a globe, signifying the conquest of the world by Christianity.

21. The Eastern Orthodox Cross has three bars across the vertical bar. The lowest bar is slanted. The reason generally given for the slant on the lowest bar is that the Russians believed that our Lord's limbs were of unequal length. One writer suggests that a reference is given in that manner to Saint Andrew's Cross, since a Russian tradition holds that St. Andrew introduced Christianity into Russia.[1]

22. The Patriarchal, or Archepiscopal, Cross has two horizontal arms on the one vertical piece. The top arm is shorter than the other.

23. The Cross of Lorraine likewise has two horizontal arms, but the lower one is nearer the base than in the Patriarchal Cross.

24. The Papal Cross has three horizontal bars. It is used only in processions when the Pope takes part.

Christ's Passion, or suffering between the Last Supper and his death, is symbolized chiefly by the cross, but also by the reed and crown, the crown of thorns, the winding sheet, blood, the spearhead, the lantern, the cock, the pillar, the thirty pieces of silver, the two scourges, the three dice, the

[1] Webber, F. R.: *Church Symbolism*, p. 106.

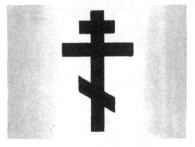

THE EASTERN ORTHODOX CROSS

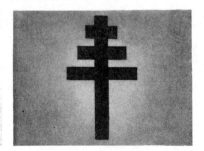

THE PATRIARCHAL CROSS

hammer and pincers, the sponge, the ladder, a skull, and the three nails.

Jesus predicted that if he were lifted up, on the cross and into heaven, he would draw all men unto him. A comprehensive interpretation of the cross is that it is the symbol of the Christian faith, the love of God for sinful man, and triumphant hope.

THE CROSS OF LORRAINE

THE PAPAL CROSS

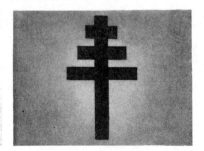

✦ THE WORD OF GOD ✦

THE TWO TABLETS The two tablets, often pictured in church win-. dows, symbolize the Ten Commandments which constitute the fundamental moral law for both Jews and Christians.

The Ten Commandments are sometimes called the decalogue, or the ten words. They were written on two tables, which are called tables of the covenant. The original decalogue probably had but short sentences; otherwise they could not have been written on the two tables of stone. The commandments may be found in Exod. 20:2-17 and Deut. 5:6-21.

THE OPEN BOOK An open book, often pictured on religious publications and stained glass windows in. our churches, refers to the Holy Bible, the Word of God. The opened book indicates that the Bible is accessible throughout most of the world. Translations of the Bible, or portions of it, have been published in more than a thousand tongues.

THE TWO TABLETS

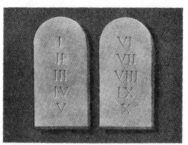

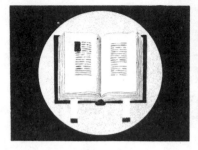

THE OPEN BOOK

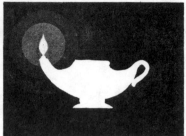

THE LAMP

A LAMP To the ancients a lamp was not merely a light for darkness, but also a symbol of intelligence and learning. Even today the lamp stands for wisdom and knowledge; likewise, the torch is a symbol of enlightenment and religious fervor.

A picture of the oldest type of lamp known is sometimes found on the cover of worship programs, on wood altar stands or desks, and in religious periodicals. Church people usually associate the familiar quotation from Psalm 119:105, with this type of lamp:

> Thy word is a lamp to my feet
> And a light to my path.

APOSTLES AND EVANGELISTS

THE APOSTLES The apostles are sometimes symbolized in twelve art glass windows, in rose windows with twelve petals, on twelve shields, or in wood carvings.

1. Peter, the early leader of the apostles, was the first to say that Jesus is "the Christ, the Son of the living God" (Matt. 16:16). It was Peter who denied three times that he knew Jesus "before the cock crows twice" (Mark 14:72), an incident memorialized by a cock pictured as crowing. Later he occasioned the first great increase in the Church through the sermon delivered at Pentecost, and he made many missionary tours.

There are numerous stories concerning the death of Peter. The story that is most popular relates that he was unwilling to die on the cross in the same position as his Master was crucified. Those who hold to this manner of Peter's death sometimes symbolize him by forming a cross with the horizontal bar toward the bottom of the vertical bar. While the humility of Simon Peter in this story is heartening, the manner of his death, probably as a martyr in Rome at the close of Nero's reign, is uncertain.

Simon Peter is usually symbolized by two keys that are crossed in the form of the letter X. The keys refer to Matt. 16:19, where it is recorded that Jesus said to Peter, "I will give you the keys of the kingdom of heaven, and whatever you bind on earth shall be bound in heaven, and whatever you loose on earth shall be loosed in heaven." Reference is made to heaven and earth when one key is gold and the other is silver. The two keys represent the power to bind and absolve (loose). They are also symbolical of the spiritual authority of the Church (See Matt. 18:18).

2. Andrew was a fisherman with his brother Simon Peter. His intimate friends were James and John, who also became ardent disciples of Jesus.

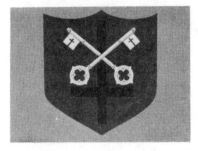

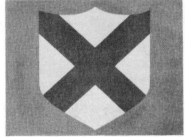

ST. PETER ST. ANDREW

Andrew was bound to a cross, rather than nailed, in order to prolong his suffering. The most common symbol of St. Andrew is a cross shaped like an X. Sometimes two fishes crossed to form the same design are used. At other times two fishes placed in his hands to show that he was a fisherman (Matt. 4:18) are found in symbolism.

3. James the Greater, who is often referred to as Boanerges, James Major, or James the Elder, was one of the closest friends of Jesus, as we gather from the Bible when references are made to "Peter, James, and John." James was the first of the apostles to suffer martyrdom, dying under the sword of Herod Agrippa I (Acts 12:1-2); here we find partial fulfillment of Jesus' prediction that the brothers should indeed drink of the cup.

Stories abound which tell of James founding churches in Spain. The symbolism of James the Greater usually consists of three scallops, referring to long pilgrimages; or the pilgrim's staff; or a pilgrim's cloak, with hat.

4. In company with Zebedee, his father, and James, his brother, John's early life consisted largely of fishing in the Sea of Galilee. John was a quiet and thoughtful man. The Bible refers to him as "the disciple whom Jesus loved." When Jesus was crucified, John took Mary, Jesus' mother, and provided a home for her through the remainder of her life.

The serpent issuing from the common cup is St. John's most usual symbol. There is an interesting story connected with it that an attempt was made to poison John, but the attempt was unsuccessful because the poison vanished in the form of a serpent. A more probable basis of the cup as the symbol of John is the reference of Jesus that John and James should drink of his cup.

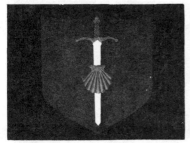

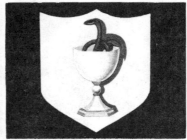

ST. JAMES, THE GREATER ST. JOHN

Sometimes John is symbolized by an eagle rising from a large cauldron or kettle, referring to his miraculous deliverance without injury from the Emperor Domitian who tried to take his life by putting him in burning oil. Sometimes a book or scroll is added to the eagle because for centuries it was believed he wrote the fourth Gospel, three Epistles, and Revelation.

5. Philip introduced Nathanael to Jesus, advising him wisely to "come and see" (John 1:43-51) if any good thing could come out of Nazareth. It was Philip who said to Jesus, "Lord, show us the Father, and we shall be satisfied" (John 14:8).

Philip is symbolized by a staff surmounted by a cross. Sometimes a small cross is shown in his hand. Usually two loaves of bread are pictured, one on each side of a cross, to symbolize him. The staff and cross refer to his successful missionary journeys among the barbarians in upper Asia and Phrygia, where he spread knowledge of Christianity and the cross of Christ. The cross may also refer to the power of the cross over idols or to Philip's manner of death, although there is no conclusive evidence that he was crucified. The loaves of bread recall Philip's remark when Jesus fed the multitude: "How are we to buy bread, so that these people may eat?" (John 6:5).

6. Bartholomew and Nathanael are held to be names for the same person, about whom the Bible tells very little. Jesus said of him, "Behold, an Israelite indeed, in whom is no guile!" (John 1:47).

According to traditional information, Bartholomew won King Polymus of Armenia for Christianity. But it happened that the brother of the king was so angry at Bartholomew that he had him flayed, crucified with his head downward, and even beheaded.

31 ·

ST. PHILIP

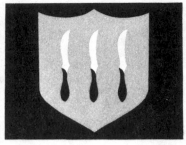

ST. BARTHOLOMEW

The symbol of Bartholomew is three flaying knives or one flaying knife, referring to his martyrdom. Sometimes he is pictured with a book (the Gospel according to Matthew) in one hand, or with an open Bible and a flaying knife.

7. Thomas, the seventh apostle according to Matt. 10:3, was also known by the name of Didymus, meaning "twin." The best known incident with which Thomas was connected is recorded in John 20:25: "Unless I see in his hands the print of the nails, and place my finger in the mark of the nails, and place my hand in his side, I will not believe."

The carpenter's square, a vertical spear, or a lance, or an arrow are the symbols of Thomas. Some writers say that Thomas built a church in India, doing much of the work himself. The square or rule refers to him as the builder or carpenter. The spear, lance, or arrow refers to his supposed martyrdom at the hand of King Midsai for converting Queen Tertia, the king's wife, to Christianity.

ST. THOMAS

ST. MATTHEW

8. Matthew, whose original name was Levi, was a tax collector when Jesus said to him, "Follow me" (Matt. 9:9). Numerous symbols for him are used: three money bags, a purse, a chest, and a battle-ax. The purses or money bags refer to his occupation as publican or tax gatherer before becoming an apostle (Luke 5:27). The battle-ax refers to his martyrdom, which is said to have taken place in Ethiopia where he was crucified on a Tau cross and decapitated with a battle-ax.

9. James the Less, the son of Alphaeus, is also called The Little because of his small stature; often he is referred to as The Minor.

According to tradition, James at the age of ninety-six was thrown from the Temple by the Pharisees, and an infuriated mob stoned him as he prayed God to forgive them, and someone repeatedly beat his head with a club. Ever since, James the apostle is represented by a fuller's bat or club. He is shown in paintings as leaning on a club. However, he is symbolized at times by a saw with the handle uppermost, and again by three stones.

10. Jude was referred to as Thaddaeus, Labbaeus, or Judas Lebbaeus. The Bible records but one question that he ever uttered, "Lord, how is it that you will manifest yourself to us, and not to the world?" (John 12:22). Tradition has it that he traveled with Simon as a missionary.

Jude is symbolized by a sailboat with a mast in the shape of a cross, or a long staff with a cross at the end, referring to his missionary journeys. Where the symbol of the lance or halberd (a weapon somewhat like a long-handled dagger) is used, reference is made to martyrdom. Sometimes the lance is combined with a club and a cross upside down.

11. Simon was a member of the Zealot party. He was successor to James the Just as bishop of Jerusalem.

ST. JAMES, THE LESS

ST. JUDE

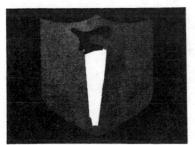
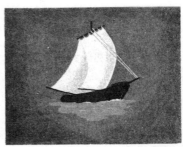

A fish on a book is the symbol of Simon. The fish refers to his success in fishing for men through the gospel. Sometimes one or two oars appear on the shield with a battle-ax or a saw. He was another martyr of the faith, having either been "sawn asunder" or beheaded.

12. Judas Iscariot was the treasurer in the group of the twelve apostles. He is well known as the betrayer of Jesus. When Judas is symbolized, a blank yellow shield, a money bag and thirty pieces of silver, or a rope around his neck is shown. The rope, of course, refers to his suicide.

Matthias is practically always substituted for Judas Iscariot. The story concerning the election of Matthias can be found in Acts 1:15-26. The double-edged ax, in conjunction with a stone or the open Bible, is his most common symbol. Sometimes, a lance with three stones, or a book and sword are used.

Paul as one of the twelve apostles is sometimes symbolized instead of Jude. His usual symbol is an open Bible with a sword behind it. The Bible bears the inscription *Spiritus Gladius,* meaning "Sword of the Spirit." Sometimes he is represented by two swords crossed, the one having reference to the good fight of faith that he fought, and the other to his martyrdom by the sword. Other emblems are the armor of God and a palm tree.

THE FOUR EVANGELISTS

The four evangelists are frequently symbolized in art windows, stone, embroidered cloth, or on the walls of some of our churches.

1. Since it is thought that his Gospel dwells more on the human side of Jesus Christ than the other Gospel records, Matthew is usually pictured as a winged man. Sometimes, however, he is pictured with a book or a pen, with an angel in the background dictating or pointing to heaven.

ST. SIMON

JUDAS ISCARIOT

ST. MATTHIAS

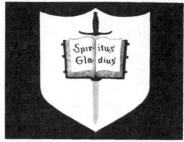

ST. PAUL

2. Mark is pictured as a winged lion. The lion, as king of beasts, represents the royal character of Christ, and refers to the opening verses of the Gospel which tell about "the voice of one crying in the wilderness." It may also be said that Mark's emphasis on the resurrection is indicated by the lion, for, according to an old fable, the cub of a lion is supposed to be born dead and after three days licked into life by its father.

3. Luke is symbolized by the winged ox because his Gospel opens with the sacrifice of Zecharias and emphasizes in the latter part the sacrificial death of the Savior. Sometimes the symbol shows the Gospel in addition to the ox.

4. The eagle denotes the evangelist John. The spirit of the Gospel of John, formerly thought to have been written by John the apostle, is like an eagle soaring to the throne of grace.

The biblical basis for the entire imagery of the evangelists may be gleaned from Ezekiel and Revelation. Ezekiel had a vision of "four living

MATTHEW, THE EVANGELIST

MARK, THE EVANGELIST

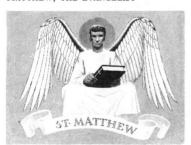

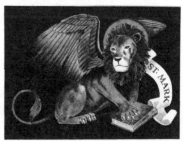

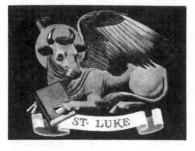

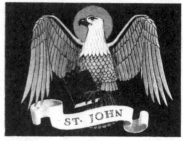

LUKE, THE EVANGELIST JOHN, THE EVANGELIST

creatures" who "had the face of a man . . . the face of a lion on the right side, the four had the face of an ox on the left side, and the four had the face of an eagle" (Ezek. 1:5-10; 10:19-22). John's vision of God's throne is similar to the one quoted above: "the first living creature like a lion, the second living creature like an ox, the third living creature with the face of a man, and the fourth living creature like a flying eagle" (Rev. 4:7).

A decorative feature often used in churches is the quatrefoil, a leaf having four foils, or lobes. The figure is symbolic of the four evangelists, the four Gospels, the four Greek doctors (Athanasius, Basil the Great, John Chrysostom, and Gregory of Nazianzus), and the four Latin fathers (Jerome, Ambrose, Augustine of Hippo, and Gregory the Great). The quatrefoil may be said to symbolize anything in fours. Sometimes the significance of the design is made more specific by placing a winged creature in each of four quatrefoils comprising a larger symbolic scheme.

THE QUATREFOIL

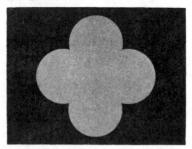

+ + THE CHURCH + + +

THE ARK From the earliest centuries of Christianity, the ark of Noah
has been a symbol of the Church. In the ark all living
creatures found refuge from the flood. The ark and the rainbow remind us
of the covenant God made with Noah, and the new covenant God made
with the Church. The symbolism of the ark is implied in churches where
a dove with a twig in its beak is pictured in a window.

THE SHIP The ship, a closely related symbol, is often used. The
imagery of the ark or ship being tossed about by stormy
waves, yet reaching its destination, is descriptive of the Church as it is op-
posed by persecution, heresy, and schism. The same imagery suggests the
New Testament story of Jesus stilling the tempest on the Sea of Galilee.
Sometimes the symbol shows the Apostles rowing the ship, and in some
symbols which may be seen in the catacombs St. Paul is pictured preach-
ing from the stern of the ship.

With a slight use of the imagination, the type of church building which is
long, high, and narrow in design can be seen to resemble a ship. In the
German churches the word *Schiff* is sometimes used to refer to the long
body, or nave, of the church building. The word nave itself is derived from
the Latin word *navis,* which means ship.

The rowers on the benches in an ancient ship may be compared to people
sitting in church pews, with Christ as Captain, the ministers as officers, and
the other workers constituting the crew. In this vein we may say that the
spires resemble the masts of the ship, with the Christian flag, or the cross
on the steeple, corresponding to the ensign. We are told that at the head of
the center aisle a model of a ship is suspended from the ceiling in some

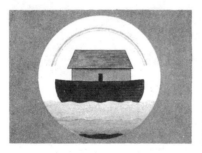

THE ARK

THE SHIP

of the Danish Lutheran churches to remind the worshipers that the Church is a ship on the sea of life.

THE BEEHIVE The beehive presents a picture of many bees working together, each in its own capacity, for the benefit of the group or entire hive. The symbol of the beehive suggests the order and organization of many human beings who function for the benefit of all. This symbol is the most modern of all symbols of the Christian Church, and is one of the best symbols for the Church that has as yet been devised.

OTHER SYMBOLS Occasionally other symbols of the Christian Church may be found. Of these the following are particularly meaningful:

1. The vine and the branches, especially when the branches have little shields representing the apostles or others in the Church who abide in Jesus Christ, may be said to symbolize the Church and its union with the Lord.

THE BEEHIVE

THE VINE AND THE BRANCHES

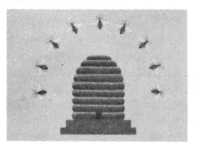

HOUSE ON A ROCK CITY ON A HILL

2. A house or a church on a rock is sometimes pictured as securely founded, like those who hear the words of our Lord and do them (Matt. 7:24-27) and confess him as the Son of the living God—the rock of faith against which the gates of hell shall not prevail (Matt. 16:16-18).

3. A city on a hill is symbolic of the stability and prominence of the Church as an influence in the world. Jesus' own words surely constitute one of the best commentaries on the meaning of this symbol:

"You are the light of the dark world: your lives reveal reality to mankind. Like yonder town on the hilltop, you are a beacon that cannot be hidden. Your influence is universal. You can see an example of God's purpose in your individual life if you think of the lamp at home. You do not light it and cover it with a bushel-basket: you put it on the lampstand that all in the room may gather round and see by its light. See to it, then, that nothing keeps your light from shining out clearly in all men's sight, so that they will notice the beauty of the things that you do, and learn to think better of your Father, God, because they have met you." (From G. R. H. Shafto's paraphrase of Matthew 5:14-16 in *The School of Jesus*.)

4. Wheat and tares, symbolizing both Christians and non-Christians in the Church, are sometimes used. The imagery here is obviously taken from one of the parables of Jesus recorded in Matthew 13:24-30: "The kingdom of heaven may be compared to a man who sowed good seed in his field: but while men were sleeping, his enemy came and sowed weeds among the wheat, and went away. So when the plants came up and bore grain, then the weeds appeared also. And the servants of the householder came and said to him, 'Sir, did you not sow good seed in your field? How then has it weeds?' He said to them, 'An enemy has done this.' The servants

WHEAT AND TARES

said to him, 'Then do you want us to go and gather them?' But he said, 'No; lest in gathering the weeds you root up the wheat along with them. Let both grow together until the harvest; and at harvest time I will tell the reapers, Gather the weeds first and bind them in bundles to be burned, but gather the wheat into my barn.' "

✛ THE OLD TESTAMENT ✛

MANY symbols have come to us from the Old Testament. We cannot describe all of them in this brief book. However, there are nine Old Testament symbols in the beautiful windows of a richly adorned Protestant church which may well constitute the outline of a brief discussion on Old Testament symbols.

1. The burning bush is a symbol of the call of Moses to deliver the Israelites from the bondage of the Egyptians, and also of the annunciation to Mary of the coming of Jesus to deliver the world from the bondage of sin (Luke 1:28-33).

2. The two tablets are symbolic of the Ten Commandments. When oak leaves form part of the background, they denote sturdiness and regeneration.

3. The seven-branched candlestick represents the Old Testament worship, the Church, and the seven gifts of the Holy Spirit. The Jews call this the Menorah and it is in common use in synagogues.

THE BURNING BUSH THE SEVEN-BRANCHED CANDLESTICK

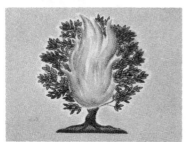 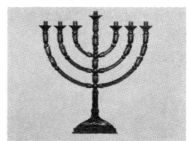

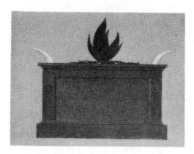

THE ALTAR OF SACRIFICE THE ARK OF THE COVENANT

4. The brazen serpent, which Moses lifted up in the wilderness, is a symbol of our Lord's crucifixion. Jesus made use of this prophetic act when he said, "And as Moses lifted up the serpent in the wilderness, so must the Son of man be lifted up, that whoever believes in him may have eternal life" (John 3:14-15).

5. The altar of sacrifice, showing red flames, refers to the Old Testament sacrifice of ritually clean animals without blemish as burnt offerings (Exod. 20:24). The ritual of sacrifice among the Israelites was highly developed, consisting of bloody sacrifices and meal offerings, burnt offerings and communal meals, sin and guilt offerings, as can be gathered from reading the early part of the Old Testament, especially the book of Leviticus. The altar of sacrifice points to the great sacrifice made by Jesus Christ in shedding his blood and giving up his life.

6. The ark of the covenant symbolizes both Old Testament worship and the presence of God. The ark is a symbol of the Savior, and the two

THE LION THE WOLF

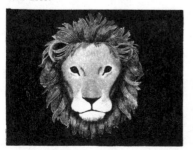
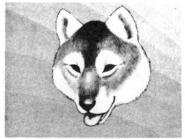

cherubim's wings form an arch of salvation. In the account of the origin of the Ark of the Covenant which appears in Exodus 25, Moses is given detailed instructions for the placement of the cherubim, as follows:

"The cherubim shall spread out their wings above, overshadowing the mercy seat with their wings, their faces one to another; toward the mercy seat shall the faces of the cherubim be. And you shall put the mercy seat on the top of the ark; and in the ark you shall put the testimony that I shall give you. There I will meet with you, and from above the mercy seat, from between the two cherubim that are upon the ark of the testimony, I will speak with you of all that I will give you in commandment for the people of Israel."

7. The lion represents the tribe of Judah, strength, courage, kingliness, and our Lord.

8. The wolf, when pictured in close proximity to the lion, is symbolic of the tribe of Benjamin. Otherwise the wolf is inseparably bound with "false prophets, who come . . . in sheep's clothing but inwardly are ravenous wolves" (Matt. 7:15).

9. The harp, pictured to represent the music of David in some instances, stands for joyful worship and for joy in heaven. The mood evoked by this beautiful symbol is well described in Psalm 150:

> Praise the Lord!
> Praise God in his sanctuary;
> praise him in his mighty firmament!
> Praise him for his mighty deeds;
> praise him according to his exceeding greatness!

THE HARP

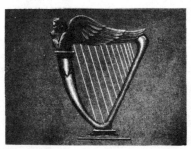

Praise him with trumpet sound;
 praise him with lute and-harp!
Praise him with timbrel and dance;
 praise him with strings and pipe!
Praise him with sounding cymbals;
 praise him with loud clashing cymbals!
Let everything that breathes praise the Lord!
Praise the Lord!

+ + WORSHIP AIDS + +

SYMBOLISM OF FORM IN WORSHIP 1. The standing position shows respect in offering praise to God. It was a position for prayer in our Lord's time, as we gather when he said, "And whenever you stand praying" (Mark 11:25), and when both the Pharisee and the publican stood praying (Luke 18:11, 13).

2. Kneeling is the normal position of the worshiper in humble and petitioning prayer. Our Lord knelt in Gethsemane when he prayed. The psalmist's appeal, "Let us kneel before the Lord, our Maker" (Ps. 95:6) has found ready response in many hearts.

3. While the customs in all denominations on the positions mentioned above are not consistently alike, bowing is practically always the accompaniment of prayer. The publican of parable fame stood when he prayed, but "would not even lift up his eyes to heaven" (Luke 18:13). Bowing is symbolic of humble respect to God, an act practically uniform throughout the world.

Bowing in the service when the name of the Lord Jesus is mentioned, and bowing toward the altar when entering and leaving the church, are customary in some churches as a mark of respect and reverence. In all places it is customary to think of the church building as the House of God and to be reverent in the sanctuary.

4. The processional march, reminiscent of Palm Sunday and Good Friday, is a formal movement leading to the public worship of God, while the recessional march symbolizes Christians going back into the world to pour the inspiration and information gained into the life of faith and the conquest of evil.

45 ·

SYMBOLISM OF THE CHURCH YEAR The cycle around which the annual worship of many congregations revolves is the church year. The first half of the church year is in itself a symbol of the life and person of our Lord, since the seasons and holy days refer to events in his life.

The Advent season, covering the four Sundays before Christmas, prepares the worshipers for Christ's coming.

Christmastide is the season when his birth is celebrated. Epiphany concerns itself with the manifestation of Christ, beginning on January 6 when Christ was shown to the wise men of the East.

The pre-Lenten Sundays, and more especially the seven weeks of Lent itself, are associated with Christ's suffering and sacrifice.

Easter and the Sundays following emphasize the resurrection of Christ.

His ascent to heaven is marked on Ascension Day, the fortieth day after Easter.

Pentecost, or Whitsunday, recognizes the descent of the Holy Spirit.

The Sunday after Pentecost is the Festival of the Holy Trinity.

The Sundays following are designated as Sundays after Trinity or Sundays after Pentecost. There are from twenty-three to twenty-seven Sundays after Trinity, depending upon the date of Easter, which may vary from March 22 to April 25. Sometimes the last Sundays in the Trinity season are called Sundays in Kingdomtide, according to a slight modification of the church year by the National Council of the Churches of Christ in the U.S.A.

SYMBOLISM OF COLORS Hangings, or antependia, on altar, lectern, and pulpit are to a church what curtains and drapes are to a home. Whenever they appear in churches, the changing colors attract, add variety, and point to the significance of the season or the festival. The same colors of the church year are used also for bookmarks and stoles.

White is the symbol of the Creator, light, joy, purity, innocence, glory, and perfection.

Violet denotes mourning and penitence, and is also symbolic of humility, suffering, sympathy, and fasting. *Purple,* equally appropriate, is frequently used instead of violet. Purple is the regal color, referring to the triumphal entry of the King of kings, who was of royal (Davidic) descent, and who is the Ruler of many hearts. Purple is also the color of penitence, refer-

ng to the purple garments put on our Lord when they mocked him (John 19:2; Mark 15:17).

Red depicts divine zeal on the day of Pentecost, and refers to the blood of the martyrs of the Church.

Green is the universal color of nature, signifying hope.

Black is the color of grief and sorrow.

To these five colors of the church year we may add *gold,* since it is used on fringes of the hangings. Gold refers to worth, virtue, the glory of God, and Christian might.

The following table shows when the various colors are used:

Festival or Season	*Color*
The four Sundays in Advent	Violet (or Purple)
Christmas	White
Sundays after Christmas	White
Epiphany and the following Sundays (Green by Episcopalians after the Epiphany Octave)	White
Transfiguration of our Lord	White
Pre-Lenten Sundays (Septuagesima, Sexagesima, and Quinquagesima Sundays) (Or Green by Lutherans)*	Violet
All Sundays in Lent	Violet
All other days in Lent, up to Good Friday	Violet
Holy Week, beginning with vespers of Palm Sunday	Violet (or Black)*
Maundy Thursday (Or White if the Holy Communion is celebrated)*	Violet
Good Friday	Black (or no paraments)
Easter and the following Sundays	White
Ascension Day and the following Sunday	White

* Strodach, a Lutheran, recommends the following changes from the General Rubrics in the Lutheran service: violet for the pre-Lenten season, black for Holy Week, and white for Maundy Thursday if the Holy Communion is celebrated.

Pentecost, or Whitsunday	Red (or White)
Festival of the Holy Trinity	White
The First Sunday after Trinity (White by Lutherans)	Green
The Sundays after Trinity	Green
Harvest Festival, Reformation Sunday, church anniversary or dedication, Martyrs' Days	Red
Thanksgiving and All Saints' Day (White by Episcopalians)	Red
Memorial Sunday	Black (or White)

FLAGS IN THE CHURCH

MANY churches have both a Christian and an American flag. The flags give warmth because of their beautiful color and design as well as the realities which they signify.

Since June 14, 1777, the Stars and Stripes, our national emblem, represent all the privileges and high ideals of America, such as freedom, opportunity, and a way of life. Even the colors of the American flag are meaningful: red is for courage; white for purity; and blue for truth and loyalty. General Washington described the symbolism as follows: "We take the stars from heaven, the red from our mother country, separating it by white stripes, thus showing that we have separated from her, and the white stripes shall go down to posterity representing liberty." Such national hymns as *The Star-Spangled Banner* and *America* are suggestive of the values symbolized by the American flag.

The Christian flag, envisioned on September 26, 1897, by Charles C. Overton, signifies Christianity in its entirety—the faith, worship, tradition, responsibilities, and all of its other blessings. The cross on the flag symbolizes the Christian religion, God's love for man as exemplified in Jesus' life and death, and the promise of eternal life. The blue background of the cross speaks of the faithfulness and sincerity of the Savior, who was obedient unto death. The white portion of the flag is symbolic of purity, innocence, and peace. The white color also bears witness to the purity and sinlessness of the Founder of the faith, and man's joy in contemplating God's initiative in redeeming the world.

The following pledges of allegiance, sometimes used in church services on Flag Day, patriots' birthdays, and the Fourth of July, might be said to summarize the symbolic significance of the flags:

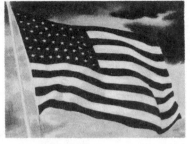

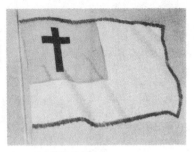

THE AMERICAN FLAG THE CHRISTIAN FLAG

I pledge allegiance to the Christian flag, and to the Savior for whose Kingdom it stands; one brotherhood, uniting all mankind in service and love.

I pledge allegiance to the flag of the United States of America and to the Republic for which it stands, one Nation under God, indivisible, with liberty and justice for all.

In place of the Christian flag, some churches substitute another. The Episcopal Church flag, adopted by the 1940 General Convention, has a large red cross on the white background with nine white Jerusalem crosses, arranged in the form of the St. Andrew's cross, on a blue field in the upper left corner. Bishop Frank E. Wilson explains that the nine small crosses stand for the nine original dioceses of the Episcopal Church in America after the Revolutionary War.

✦ ✦ ✦ VESTMENTS ✦ ✦ ✦

PROTESTANT VESTMENTS 1. With the rise of renewed interest in worship and churchliness, the practice of wearing robes in Protestant churches is more prevalent than· in former years. Robes signify humility in leading an orderly and dignified worship service. When they are used the attention of the worshipers is more easily focused on the religious messages conveyed by the words spoken or sung, and the feelings which are associated with the public service of divine worship are naturally sustained by their use. In churches where the robe is not used the atmosphere of worship is likely to be associated in the minds of members with whatever clothing the minister may wear.

The practice of confirmands wearing robes for the services of presentation and confirmation is growing in several denominations.

2. Danish, Norwegian, Swedish, and Anglican churches consider the *surplice* as part of the liturgical dress. In America we seldom see the surplice on clergymen other than those of the Roman Catholic, Episcopal, or Lutheran faith. Many choirs wear *cottas*—short, elbow-length, surplice-like garments over their cassocks. Surplices and cottas are symbolic of righteousness, innocence, and purity.

3. The *stole,* a long narrow band worn over the shoulders, signifies the ordination of the clergyman wearing it, and marks the sacredness of the sacraments. Except that the robes of Protestant clergymen are generally more elaborate than choir robes, and that some Protestant clergymen wear white tabs, signifying the two tablets on which the Ten Commandments were inscribed and the Old and New Testaments, there is nothing else in the most common Protestant vestment which signifies ordination by the church. As such, the simple vestment of the clergy emphasizes the priest-

hood of all believers: The stole gives visible evidence of theological training and ordination, and symbolizes the yoke of obedience to the Master (Matt. 11:29-30).

The more prevalent stoles for choirs become, the less it can be said that the stole is symbolic of ordination. Stoles for choirs are symbolic of the yoke of obedient service to the Master in the rendering of music to his glory.

The minister's five stoles are used according to the liturgical colors of the church year.

TRADITIONAL VESTMENTS While the ancient vestments and insignia which follow are used by Roman Catholic priests and bishops, a good many are common to Episcopalian priests and bishops and to some Lutherans, especially the Norwegian and Swedish Lutherans. In the summary of his chapter on "Vestments," an Episcopal bishop says:

> Some or all of them will be used according to taste or preference but none of them may rightly be demanded. Indeed it ought to be added that the worship and sacraments of the Church could be effectively administered with no vestments at all. Insofar as they contribute to the beauty, dignity, and reverence of public worship, they have a rightful place by force of custom and tradition. If, now and then, they have gathered some fanciful significance around them, that is only because of the respect and affection with which many devout persons regard them. At least they ought to be understood.[1]

1. The *amice* is a white rectangular or square piece of linen, formerly worn over the head, but now attached around the shoulder. The amice represents divine hope and signifies the helmet of salvation. It is reminiscent of the blindfolding of Christ (Luke 22:63-65).

2. The *alb* is a long white garment, hanging down to the priest's ankles, which is said to be symbolic of the innocence and prophetic office of Christ because it reminds one of the robe which Herod put on Jesus (Luke 23:11). Many Lutheran ministers in America today wear the surplice and stole over the black cassock for general services and ministerial functions, and the cassock, alb, stole, cincture, and a simple linen chasuble for Holy Communion and church baptisms.

[1] Wilson, Frank E.: *An Outline of Christian Symbolism*, p. 55.

3. The *cincture,* a girdle made of linen, wool, or silk, is symbolic of the scourge ordered by Pilate (John 19:1). This vestment is worn around the waist to hold the alb close to the body and to keep the stole in place. It is symbolic of continence, self-restraint, chastity, and patient suffering.

4. The *maniple* is an ornamental band worn on the left arm. It is said to refer to the bands which held the wrists of our Lord in Gethsemane, also when he was scourged, and later when he was dragged through the city of Jerusalem. The maniple is symbolic of spirituality, strength, endurance, good works, and the order of the subdeaconship.

5. The *stole,* as previously mentioned, is a long band which hangs on both sides in the front. It represents immortality, the yoke of obedience, and the reign of Christ.

6. The *chasuble,* a large vestment hanging down in the front and back of the priest, signifies Christian charity. It is reminiscent of the purple garment worn by Jesus before Pontius Pilate.

To summarize, we may imagine that we are in the sacristy watching a clergyman put on his ancient vestments. The first vestment he puts on over the cassock is the amice. Next, he puts on the alb. Then he draws up the loose alb with the cincture. He proceeds to put the maniple over the left arm. Then he hangs the stole around his neck. The last vestment he puts on is the chasuble.

Whatever vestments the minister may wear to honor the tradition of his Church or to meet the requirements of his own taste and conviction, his constant prayer as he stands before his people is expressed in the words of the hymn by Denis Wortman:

ROBE, SURPLICE, AND STOLE

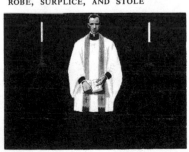

God of the prophets! Bless the prophets' sons;
Elijah's mantle over Elisha cast;
Each age its solemn task may claim but once;
Make each one nobler, stronger than the last.

Anoint them prophets! On thy service bent,
To human need do thou their hearts awake,
With heavenly speech their lips make eloquent
To preach the right, and every evil break.

Anoint them priests! Strong intercessors they
For pardon, and for charity and peace!
O that with them might pass the world, astray,
Into the dear Christ's life of sacrifice!

Make them apostles! Heralds of thy cross,
Forth may they go to tell all realms thy grace;
Inspired of thee, may they count all but loss,
And stand at last with joy before thy face.

+CHURCH EQUIPMENT+

THERE are several things about church equipment which ought to be mentioned because they are so closely related to church symbols as to be inseparably connected with them.

1. Church bells convey an inner meaning, calling the worshipers to come and give the worship and adoration that are due God.

2. The tower, especially when it is massive and sturdy in appearance, calls to mind the name of God who is a strong tower (Prov. 18:10) to whom we should come for refuge.

3. The steeple in a few localities is surmounted by a hand with the first finger pointing heavenward. An outstanding feature of the landscape, the steeple or spire, pointing toward the blue of heaven, is a silent witness to the one true God whom the people come to worship in the church. Some spires culminate in the cross at the top, signifying that God loves the world and is reconciling the world unto himself through the worship, meditation, prayers, and hymns of the people in the church below. A weather vane atop the steeple points to the wind and changes with the wind—a challenge to face difficulties and a warning to beware of changing with every wind of doctrine (Eph. 4:14). The weathercock refers to Peter's denial of Christ and bids the Christian to be humble. When there are two spires of equal proportions the two natures of Jesus Christ are symbolized.

4. The church door itself may remind one of Jesus who said, "I am the door" (John 10:9). In our prayers we approach the heavenly throne "through Jesus Christ our Lord." When a door is divided in such a way as to make two entrances, references are again made to the two natures of

TOWER AND STEEPLE

Christ. The large open doors welcome everyone, bidding all to advance into the church to worship, learn, and serve.

5. The pillars, the chief support of the church, give silent witness to the apostles and prophets (Eph. 2 and Gal. 2:9) and other leaders of the Church. Even the arches above the door and windows have symbolic significance. Since the arches join together the pillars and the walls of the church, they may serve the imaginative as reminders of Jesus Christ and the sacraments by which God and man are joined together. The arch is also said to be symbolic of the beneficence of God and the hospitality of the Christian faith. The rounder form of arch may be said to suggest authority and dependability, because of the massive and rugged character of many buildings of this type. The Gothic form of arch, high and pointed, suggests aspiration and feeling.

6. The steps or stairs signify the Christian pilgrimage, or the pathway of the Christian who seeks to worship God and to learn his ways.

7. Upon entering the main body of a church building, one looks to the altar or Lord's table at the far end. When there is a center aisle, which in itself is a symbol of the way that leads to the throne of God, the eye naturally focuses on the altar. The altar is a large appointment. When shaped like a tomb, it is reminiscent of the catacombs when Christians celebrated the Lord's Supper upon the tombs of martyrs. When it is shaped like a table, it reminds one of the table in the upper room when the Lord's Supper was instituted. The altar in the Christian churches is the symbol of Christ's sacrificial death, further illustrated by the bread and wine in the sacrament. The altar is the throne of God in his house. It is an everlasting symbol of his spiritual presence in the church.

The offering of the people is placed on the altar, symbolizing their sacrifice to God. The thought of laying one's sacrifices on the altar is a familiar one throughout Christendom.

8. Some churches have both a chancel and a sanctuary; the sanctuary is the area closest to the altar, set apart by altar rails, and the chancel is the area between the sanctuary and the nave. The nave is the long body of the church. When there is only one area in addition to the nave, where the congregation worships, the whole section around the altar is often called the chancel. If there is a screen or rail separating the chancel or sanctuary from the nave, the rail marks off the Church Triumphant from the Church Militant. Many churches have a rood beam stretched across the arch leading into the chancel; it is above the chancel screen.

Since the technical terms for the areas within a church building are not widely known, the growing practice of calling the entire interior of the church "the sanctuary," meaning a sacred or holy place, is a welcomed improvement over the word "auditorium," a place for hearing.

The apse in a church is the semi-circular, oblong, or polygonal extension of the walls and ceiling around and behind the altar. The clerestory is the part of the church building which is higher than the roofs of the other parts; it usually contains windows. When the outer walls of a church form a cross-shaped or cruciform building, the parts of the church which correspond to the horizontal bars of the cross constitute the transept. The transept crosses the church between the chancel and the nave and extends farther on the sides than the walls of the long nave. The narthex is the ecclesiastical word for vestibule.

9. Many churches have two pieces of furniture which uphold the Word of God. These are the pulpit and the lectern. When this is the case, the larger piece of furniture is the pulpit and is used for the exposition and application of the Word. Occasionally the pulpit and the lectern are built identically. The octagon-shaped pulpit symbolizes the regenerating power of God's Word, which is transmitted through the personality of the minister.

The lectern, usually smaller than the pulpit, stands as a single appointment for the reading of the Scriptures. When a lectern has the wings of an eagle upholding the Bible, reference is said to be made to the gospel taking flight to all the world (Matt. 24:14). A pelican feeding her young from her breast refers to the atoning work of Christ (John 6:53). When a

doubleheaded lectern is used, the Old and New Testament, the Law and the Gospel, the Epistles and Gospels, are symbolized.

When there is a single piece of furniture from which the minister preaches, reads the Scriptures, and offers prayer, the churches generally refer to it as the pulpit.

10. Two books in the Protestant churches, in addition to the Bible, call sacred associations to the mind. The hymnal has come to symbolize the Christian religion as it is loved in musical participation. The Book of Worship is likewise symbolic of the Church at large and the continuity of the present-day Church with the Church of the past.

11. Aside from the symbolic references in specific stained glass windows in numerous churches, windows in general may be said to symbolize the Christian life. As windows are open to let the warmth and light of the sun come in, so the Christian at his best is open to good thoughts and good words, and closed to the things that harm as a window is closed to wind and rain. As windows can be beautiful when they let the sunlight pour through them, so human life can be radiant and rich with Christian grace when the light of Jesus Christ shines through.

12. Display pipes are symbolic of a great instrument of praise. Like the harp, display pipes symbolize joy and music. Good church music has rightly been called "the daughter of heaven," and a pipe organ "the king of instruments."

The symbolic values of the baptistery are discussed in Chapter 16.

+ STARS AND CANDLES +

STARS The number of points in a star is significant in Christian sym-
 bolism. Perhaps the five-pointed star, often used in connec-
tion with the celebration of Christmas, is the most familiar.

1. The four-pointed star is interpreted as forming a cross.

2. The five-pointed star is symbolic of the Epiphany, or the manifested
nature of God. In Matt. 2:2, it is recorded that the wise men came from
the east and asked, "Where is he who has been born king of the Jews? For
we have seen his star in the east, and have come to worship him." The
five-pointed star is the star "out of Jacob" (Num. 24:17), Jesus Christ,
"the bright morning star" (Rev. 22:16) who manifested himself to the
Gentiles. The five-pointed star usually accompanies scenes of the nativity.

With a liberal use of the imagination, this star can be said to suggest the
figure of a man (with head, two arms, and two legs), who is both "true
God and true man in one Person."

3. The six-pointed star, formed by superimposing one equilateral tri-

THE FIVE-POINTED STAR THE SIX-POINTED STAR

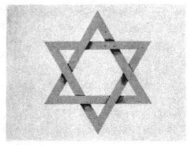

angle on another, is the Creator's star, or the symbol of creation; it doubly emphasizes the Holy Trinity in the process of creation. The six-pointed star is also used by the Jews as the star of David and the symbol of Zionism.

4. The seven-pointed star and the nine-pointed star refer to gifts of the Holy Spirit.

5. The eight-pointed star symbolizes regeneration. The number eight is traditionally associated with the idea of regeneration or baptism.

CANDLES 1. Candles symbolize Jesus Christ, the Light of the world. When one candle appears on each side of the altar the two natures of Christ, divine and human, are emphasized.

2. Six candles on each side of the altar signify that our worship is never perfect. The number six is considered the imperfect number. Sometimes it refers to the six attributes ascribed to the Creator: wisdom, majesty, power, love, mercy, and justice.

The six candlesticks also represent the six days of creation. In this instance, the cross on the altar may be said to symbolize the day of redemption. Some say that the six candles stand for the six hours our Lord spent on the cross.

Candelabra, or branch candlesticks, carry three, five, or seven candles on each candelabrum.

3. The number three refers to the Holy Trinity.

4. The number five has a three-fold meaning. The first reference is to the five foolish and the five wise virgins. When the five lights on each candelabrum are lit, each group represents the five wise virgins who were prepared to meet the Bridegroom. When the candles are unlit, they represent the five foolish virgins who tried in vain to borrow oil from their wiser companions. The five burning lights should remind the worshiper to be ready to share in the feast of the kingdom of God.

The second reference of the number five is to the five wounds of Christ, which are the nail wounds in each of the Master's hands and feet, and the spear wound in his side.

The third reference of the number five can be directed to the words of St. Paul, "Nevertheless, in church I would rather speak five words with my mind, in order to instruct others, than ten thousand words in a tongue" (1 Cor. 14:19). In a day when little groups here and there emphasize

"speaking in tongues," one could do worse than to underline this interpretation of the number five.

5. The number seven is regarded as the perfect number, as it is the total of four and three. Four is a "man number," referring to the seasons of the year and the "corners" of the earth. Three is a "God number," everlastingly associated with the Blessed Trinity. A seven-branched candlestick on each side of the altar may be said to refer to the perfect life of Jesus. But the seven lights on the candelabrum symbolize mainly the seven gifts of the Holy Spirit which are listed in Chapter 3, the seven churches (Rev. 1:20), and the Old Testament (Exod. 25:36-37).

During the Middle Ages the number seven was considered a mystical number. There were seven days of the week, seven penitential psalms, seven gifts of the Holy Spirit, seven churches in Asia Minor, seven mysterious seals, and seven heads of the Dragon.

If more than seven candles are used, additional emphasis is possibly given to Christ as the Light of the world. Albert W. Palmer rightly deplores the extreme practice he observed in a church where he found one hundred and twenty-one candles in the chancel!

Many candles are appropriately used, however, in such candle-lighting ceremonies as have come into wide use during recent years. In watch-night services, for instance, a leader lights his own candle from a large candle on the altar which is understood to represent Jesus as the Light of the World. He passes on the light to a small number of worshipers who pass it in turn to all the members of the congregation.

It has become a tradition in many summer camps and conferences to end the program with a candle-lighting service which begins at the council circle. The only light in the darkness is that which rises from a fire in the

CANDLES FOR HOLY COMMUNION

CANDLES FOR MORNING SERVICE

center of the circle. The fire may have been lighted by a camper, using the words of John Oxenham's poem, "Sacrament of Fire":

> Kneel always when you light a fire!
> Kneel reverently, and thankful be
> For God's unfailing charity,
> And on the ascending flame inspire
> A little prayer, that shall upbear
> The incense of your thankfulness
> For this sweet grace
> Of warmth and light!

The director or some appointed member of the staff lights his candle at this central fire and then, in ways that differ from camp to camp, the light is relayed to the whole circle of campers. The service ends usually with an impressive ceremony during which the candles are lifted high in token of personal dedication. The campers then leave the council fire in single file and return, carrying their lighted candles, to their several cottages.

ALTAR CANDLES What shall we say about the use of altar candles?
 Traditionally, one candle is used on each side of
the altar during the celebration of Holy Communion. Six candles are used on each side in the regular morning service. Three, five, or seven candles on each side are used in vespers or evening services.

Today, however, usage varies so greatly that it cannot be said that the traditional is the only right way to use candles. Candelabra are used in many of our churches for all services. Likewise, two candles are used in many churches for every service, whether the sacrament of the Lord's Supper is celebrated or not.

✛ CHRISTMAS & EASTER ✛

CHRISTMAS Christmas cards of a religious nature contain picture-
symbols appropriate for that section of the year. One
might wish that Christians were more conscious of the religious significance
of this season and more thoughtful in their selection of their greeting
cards!

1. The picture of the Christ Child is symbolic of God's nearness to man
and God's initiative in the redemption of man.

2. The crib or the manger suggests the lowliness and poverty surround-
ing the infant Savior, who for humanity's sake became poor, that through
his poverty people might become rich (2 Cor. 8:9).

3. Berries, the blossoming rod, and many other decorations may sug-
gest Christmas, but do not point to specific religious values. Holly leaves
are said to be most beautiful when the lights are low, symbolizing the
beauty of the Good News in a dark world. Evergreens may be interpreted
as symbolizing the everlasting love of God.

EASTER Among the symbols for Easter, we will consider the butter-
fly, the Easter lily, the pomegranate, the phoenix, and the
peacock. The resurrection banner has been discussed in Chapter 2.

The tradition for making comparisons of the resurrection of Christ to
events in nature dates back to St. Paul, who wrote: "And what you sow
is not the body which is to be, but a bare kernel, perhaps of wheat or of
some other grain. But God gives it a body as he has chosen, and to each
kind of seed its own body" (1 Cor. 15:37-38).

1. The butterfly is a symbol of the resurrection and eternal life because
it emerges with a glorified body able to soar into the sky, from the cocoon or

THE MANGER

THE BUTTERFLY

chrysalis, which in turn comes from the caterpillar, and the caterpillar from the egg.

2. The Easter lily is a common symbol of Easter, used in Easter services of worship. It blooms around Easter every year.

3. The pomegranate is suggestive of Easter because of the many seeds in the fruit. The fruit is about the size of an orange, with a reddish-yellow rind, and juicy red pulp. The pomegranate is also symbolic of the fertility of the Word and the richness of divine grace.

4. The phoenix is a popular symbol of Christ's resurrection, or the resurrection of those who fall asleep in him. The phoenix is an imaginary bird, resembling an eagle, which is said to live five hundred years in the Arabian desert. It is then consumed by a fire, but rises again, fresh and beautiful, from its own ashes. It is usually pictured above flames.

5. The peacock has also been used to symbolize eternal life, resurrection, and immortality, because of the annual renewal of its beautiful plumage. But in recent times the peacock is more frequently thought of in connection with pride and vanity because of its long, richly colored tail-feathers which it so proudly displays.

✛ HOLY SACRAMENTS ✛

HOLY BAPTISM The baptismal font, or the baptistery, is a symbol of the Church's belief in the sacrament of Holy Baptism. If the font or baptistery has seven sides, it symbolizes creation; eight symbolize the new creation—regeneration. When the font is circular in shape, the beginning of eternal salvation is emphasized. A quadrilateral font or baptistery speaks silently of people coming from four directions (Luke 13:29). When the font is near an entrance to the church, admission into the church through baptism is signified.

Because they symbolize God's reception of the baptized member as his own, representations of either the font or baptistery may be used on baptismal certificates.

A dove, symbolic of the Holy Spirit, sometimes adorns the font. Palm branches, signifying victory, often adorn the baptismal bowl. When there is a cross on the font or cover of the font, regeneration is silently emphasized. When three fishes are placed in the form of a triangle, the triune God into whose name persons are baptized is indicated. Quite frequently an angel of stone is made to hold the baptismal bowl. This leads us to recall that "there is joy before the angels of God over one sinner who repents" (Luke 15:10).

Two stags drinking also symbolize Holy Baptism.

Churches which immerse often have the baptistery in back of the communion table or altar, separated by a curtain. The act of baptism by immersion gives emphasis to being buried with Christ and rising again with him in newness of life.

HOLY COMMUNION 1. The most important symbol for the sacrament of Holy Communion is the chalice.

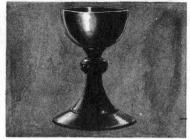

THE BAPTISMAL FONT THE CHALICE

Similar to the actual cup used by Jesus at the institution of the Lord's Supper, which was eventually lost, the chalice is sometimes rich with ornamental design. In carvings and paintings the wafer or host is inscribed with an IHS monogram, or the letters INRI, with half of the wafer showing above the chalice. Occasionally the stem of the chalice is wreathed with a crown of thorns, reminding one of our Lord's passion. Notwithstanding the fact that, for hygienic reasons, communion trays with individual cups for the distribution of wine are being used more and more in churches, the symbol of the chalice remains as a beautiful and blessed reminder of the cup which our Lord took and blessed at the Last Supper.

2. The altar itself is frequently rich with suggestions pertaining to the Holy Communion. Carvings with bunches of grapes, vines, and branches are symbolic of the communion between Jesus Christ and the believers. In pictorial presentations, the altar with cross or crucifix, candlesticks, and chalice symbolize the sacrament. Sprays of wheat or wheatbreads carved on or about the altar symbolize the Bread of life and the bread which is used in Holy Communion.

3. On its literature for World Wide Communion Sunday the National Council of the Churches of Christ in the U.S.A. pictures two views of the globe above or in the background of the cup. When the outlines of the continents and oceans are visible, it is particularly effective in reminding one of the universal scope of this celebration.

ADDITIONAL SYMBOLS+

1. The dove is a symbol very often found. While it is the symbol of the Holy Spirit as we mentioned in Chapter 3, the meanings attached to this symbol throughout Christian history have varied.

The picture of the dove with an olive leaf in its mouth refers to the story of the flood recorded in Gen. 8, and symbolizes the deluge, victory, and an expectation of new life.

In the early centuries of the Christian movement the dove was pictured on monuments, expressing the innocence of the loved ones who were committed to the Lord's keeping. The association between the dove and rest may be seen in the statement, "Oh that I had wings like a dove! I would fly away and be at rest" (Ps. 55:6). Jesus had told his followers to be "innocent as doves" (Matt. 10:16), so the dove engraved on burial monuments may well have expressed the conviction that the person thus commemorated was innocent and pure in heart. The dove with an olive leaf or palm branch in her beak on burial monuments today is symbolic of eternal peace won. Pictures showing the dove emerging from the mouths of dying martyrs indicate that the dove is also emblematic of the soul.

In religious art the Savior is sometimes surrounded with seven doves, which represent the gifts of the Holy Spirit. Sometimes each dove holds a scroll in her beak with a virtue inscribed on it in Latin.

Two additional variations must be mentioned. When a pair of turtle doves is shown, reference is made to the presentation of Jesus in the temple. The dove pictured above the waters is symbolic of creation (Gen. 1:3), especially when the artist indicates the deity with a three-rayed nimbus.

2. While a note explaining the nimbus was given in the first chapter, additional information might not be out of place. The nimbus surrounds

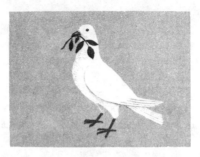

THE DOVE

the heads of sacred persons and symbols in circular form, and surrounds persons honored while still living in rectangular or square form. Sometimes the light of the nimbus takes the form of rays of light, again as jewels adorning the sanctified, and again as a mere circle of light.

Sometimes rays of light seem to emanate from the entire body of our Lord. The elongated irradiation of light is called the aureole.

A tri-radiant nimbus surrounds the head of the Lamb, the Dove, and other symbols of God.

3. The sheaf of wheat is a symbol of God's bounty, conveying the thought that every year, practically without fail, there is a harvest to be garnered from the fields. God is good! He "makes his sun rise on the evil and on the good, and sends rain on the just and on the unjust" (Matt. 5:45).

As God enables mankind to garner a harvest from the earth, he makes it possible to reap a spiritual harvest. St. Paul gave a summary of this law of life when he wrote: "Do not be deceived; God is not mocked, for whatever a man sows, that he will also reap. For he who sows to his own flesh will from the flesh reap corruption; but he who sows to the Spirit will from the Spirit reap eternal life. . . . In due season we shall reap, if we do not lose heart" (Gal. 6:7-9).

The sheaf of wheat combined with a sickle is a symbol of the harvest and a reminder of the autumn of life.

4. Sometimes we find a red heart pictured in art glass windows. The heart is the everlasting symbol of both love and will power. The biblical references to the heart of man in the following typical examples bring out the meaning: "Thou shalt love the Lord thy God with all thy heart"; "I will give thanks to the Lord with my whole heart" (Deut. 6:5; Ps. 9:1).

The statements refer to the vital or essential part of a human being, love and will power. If one substitutes this combination for the word "heart," the interpretation will be true to the symbolism of the heart. God commands his children to love him with their whole love and will power; and they should give thanks unto him with their whole love and will power.

A heart surmounted by a flame signifies intense zeal or devotion.

When the symbol of the heart is combined with cross and anchor, as on some bookmarks, bracelets, necklaces, and church steeples, the meaning of the symbols is simply stated by referring to the three as "Faith, Hope, and Love." Faith refers to the cross, hope to the anchor, and love to the heart. Speaking of faith, hope, and love, St. Paul wrote, "the greatest of these is love" (1 Cor. 13:13).

5. Pictures of hands convey various meanings, depending on their position. Two clasped hands beneath the extended hand of God signify the blessing of marriage by the Church. On a tombstone, two clasped hands signify farewell and welcome. The palms of two hands together, fingers upward, such as those pictured by Albrecht Dürer, suggest worship and adoration. Folded hands are symbolic of prayer.

6. A trumpet is symbolic of the day of judgment, the call to worship, and the resurrection.

7. Birds are symbolic of human souls.

8. A hen with chickens is symbolic of the solicitude of our Lord. He said, "How often would I have gathered your children together as a hen gathers her brood under her wings" (Matt. 23:37).

9. The shield is symbolic of protection and faith.

10. The swan is a symbol of the hypocrite because of its black flesh beneath the white plumage. A "swan song" is symbolic of the last effort.

11. Sometimes the serpent is used as the symbol for the tribe of Dan (Gen. 49:17). At other times the serpent is the symbol of wisdom (Matt. 10:16). Previously we mentioned that a serpent surrounding a tree is a symbol of the fall of man. A serpent wrapped around the globe is a symbol of the spread of sin.

The serpent must be interpreted in relation to the other symbols which appear in art window, picture, or mosaic. Concerning the difficulty of understanding the serpent symbol, Goldsmith says, "No symbol has a more

confused variety of meanings—good, evil, life reproduction, wisdom, power, eternity—everything also that is base, dark, evil, low."[1]

FLOWERS There are a vast number of objects in Christian tradition which are charged with great meaning. Some of them have risen to the full rank of symbols. Others are nearly symbolic in meaning.

Generally speaking, flowers are symbolic of the beauty of God and the resurrection of Jesus Christ. The following flowers have specific meanings as well:

1. The Christmas rose symbolizes the Nativity of our Lord. Margaret Ann Ahlers, a writer for *The Dayton Journal* (December 13, 1941), traced the known history of it and indicated the deep significance which may be derived from its survival through the centuries in spite of snow and storms. The flower grew abundantly in the first century; it was especially beautiful on Mount Helicon. The rose was first called the white rose when people began to notice that it would stand the ravages of winter; later it was named the Christmas rose when they noticed that it bloomed just at Christmas time. Miss Ahlers reminded that "despite wars which shake the whole earth, there still exists a mighty power which can shape a rose or lead shepherds to a king."

2. The Christmas starwort likewise stands for the Nativity.

3. The daisy is the emblem of the Christ Child's innocence, innocence in general, and youth.

4. The Easter lily, as stated previously, is a symbol of Easter because it blooms at that time.

[1] Goldsmith, Elizabeth: *Life Symbols as Related to Sex Symbolism,* p. 137.

THE CHRISTMAS ROSE

5. A very popular design is the fleur-de-lis, said by some to be the conventional form of the lily, by others that it originally represented an iris. It is a symbol of the Holy Trinity, the Annunciation, Mary the mother of Jesus, the human and divine natures of Jesus Christ when it is combined with an IHC, and the French monarchy.

6. The gladiolus represents the incarnation, the Word made flesh.

7. The lily of the valley means humility, purity, Mary the mother of our Lord, and our Lord himself (Song of Sol. 2:1) because he was humble (Phil. 2:6-8) and pure (1 Pet. 2:22).

8. The passion flower is emblematic of Christ's suffering. According to E. W. Leachman, a special meaning has been given to each part of this flower. The ten petals signify the ten apostles who did not deny or betray our Lord: the rays within the flower are the crown of thorns; the five stamens refer to the five wounds of Jesus on the cross; the three styles remind one of the nails; the leaf is shaped like a spear; the tendrils signify the cords with which our Lord was bound.[2] T. A. Stafford writes that the central column represents the pillar before the Praetorium, and the ovary the hammer used at the cross. Stafford further points out that the petals refer to the apostles who fled, omitting Judas Iscariot and John.[3]

9. The poinsettia is a flower that recently has come to signify our Lord's Nativity.

10. The rose, often used in conventionalized form on pew ends, moldings in church school class rooms, and in church windows, is the symbol of Messianic hope (Isa. 35:1), love, our Lord or his Nativity, Mary the mother of our Lord, paradise, and beauty. The rose of Sharon, like the lily of the valley, is a lovely name (Song of Sol. 2:1).

11. The sunflower is emblematic of the soul turning to Christ, because of the flower's habit of turning toward the sun; it is also symbolic of glory, gratitude, and remembrance.

12. The violet is a symbol of humility and secrecy because of its location, usually beneath hedges or in the shadow of larger plants.

[2] Leachman, Edgecombe W.: *The Church's Object Lessons,* p. 131.

[3] Stafford, Thomas Albert: *Christian Symbolism in the Evangelical Churches,* pp. 94, 95.

THE LOTUS

13. The pomegranate as a symbol of the resurrection of our Lord and the fertility of the Word was listed in Chapter 15. It is found in church needlework and carving.

14. As the lotus, having its roots in quagmire and its stem in muddy water, emerges as a flower of exquisite beauty and purity, so Christians are to rise above all passion and selfish gain.[4]

TREES The tree was worshiped as the home of a kind god or feared as the home of evil spirits. (See 2 Sam. 5:23-24 and Exod. 3:1-4.) From the manifold differences of meaning attached to tree worship, we may say that the tree symbolized immortality, wisdom, and the universe. Whittick points out that the tree becomes important in Christian symbolism because of its association with the cross, which was seen to mean eternal life and divine wisdom. The designs in older candelabra and chandeliers, and some wood altar crosses, have a visible similarity to trees.[5]

1. The acacia bush or tree is symbolic of immortality. When an acacia bush is shown enveloped by flames, the call of Moses is represented.

2. The banana tree, perpetually propagating itself from the same root, is recognized in South India as signifying continuing life.

3. The cedar tree is suggestive of growth (Ps. 92:12), height (Amos 2:9), and steadfast faith.

[4] Fleming, Daniel Johnson: *Christian Symbols in a World Community*, pp. 36-38.

[5] Whittick, Arnold: *Symbols for Designers*, pp. 120-126; Mackenzie, Donald A.: *The Migration of Symbols*, pp. 156-183; Goldsmith, Elizabeth: *Life Symbols as Related to Sex Symbolism*, pp. 93-117.

4. The cherry tree has been emblematic of truthfulness since the time of George Washington.

5. The elder tree denotes zeal.

6. The evergreen tree is symbolic of eternal life, God's everlasting love, and Christmas.

7. The fig tree denotes fruitfulness, fidelity, and St. Bartholomew (John 1:48).

8. The Jesse tree represents Jesus' royal genealogy, a favorite subject of painters in the Middle Ages. Candlesticks in the shape of a tree were called Jesses.

9. The mustard tree suggests considerable growth from a small beginning (Matt. 13:31-32 and Luke 13:18-19), and represents the Church.

10. The oak tree denotes strength (Amos 2:9), durability (and hence steadfastness), and development from a small beginning (acorn). The eight-lobed leaves of the oak suggest regeneration.

11. The olive tree refers to Jesus' peace, healing, faith, beauty (Hos. 14:6), probably the Christian Church (Rom. 11:17-24), and Gethsemane. The olive branch, ever an emblem of peace, denotes also deliverance from anxiety, referring to the dove which returned to Noah's ark with an olive branch in its beak. Hence the olive branch may be said to symbolize deliverance from the hardships of life and peaceful life with God in the world to come.

12. The palm tree or branch is the symbol of the triumphal entry of Jesus (Matt. 21:8), victory, joy, martyrdom, and prosperity (Ps. 92:1-2).

We are indebted to Francis of Assisi's "Canticle of the Sun" for one of the most meaningful and moving interpretations of the Christian attitude toward the natural world:

O most high, almighty, good Lord God, to thee belong praise, glory, honor, and all blessing.

Praised be my Lord God with all his creatures and especially our brother the sun, who brings us the day and who brings us the light; fair is he and shines with a very great splendor: O Lord, he signifies to us thee.

Praised be my Lord for our sister the moon, and the stars, the which he hath set clear and lovely in the heavens.

Praised be my Lord for our brother the wind, and for the air and cloud, calms and all weather by the which thou upholdest life in all creatures.

Praised be my Lord for our sister water, who is very serviceable unto us and humble and precious and clean.

Praised be my Lord for our brother fire, through which thou givest us light in the darkness; and he is bright and pleasant and very mighty and strong.

Praised be my Lord for our mother the earth, the which doth sustain us and keep us, and bringeth forth divers fruits and flowers of many colors, and grass.

Praise be my Lord for all those who pardon one another for his love's sake, and who endure weakness and tribulation; blessed are they who peaceably shall endure, for thou, O most Highest, shalt give them a crown.

Praise ye and bless the Lord and give thanks unto him and serve him with great humility.

NEW CREATIONS IN SYMBOLISM

THE CHALLENGE to create distinctive music, architecture, and Christian books of devotion has been sounded more repeatedly by many writers since the appearance of Von Ogden Vogt's book, *Art and Religion,* in 1929. Some works have appeared which express the modern mood. The future will bear witness to whatever lasting contributions are being made in our own time.

In the field of symbolism Clarence Seidenspinner describes new symbols in Von Ogden Vogt's First Unitarian Church in Chicago, where he found commerce symbolized by a locomotive and a steamship, and communications by a microphone and a printing press, which "have been brought into the Church for sanctification." Some concrete suggestions are offered here in the hope that they will encourage the creation of new symbols. We ought not to permit our respect for traditional symbols to keep us from a reverent use of imagination and art today.

1. The ideal of world unity ought to have a symbol. With the progressive advances made in the systems of transportation and communication, the human race is becoming more and more conscious of an underlying unity and the need for a greater unity.

2. Closely related is the idea of the brotherhood of man. A good symbol of the brotherhood of man should help to make concrete the thoughts we have on the subject and constitute an invitation to live accordingly.

3. The ecumenical spirit of interdenominational cooperation and good will has been exemplified in great conferences and written material on the subject, but not in symbolism. The cross is the most universally accepted symbol of the Christian groups, but a special symbol to signify the ecumenical attitude would help to foster world-wide Christian aims.

4. The concept of social justice, which has been given more and more prominence since the time of Walter Rauschenbusch, ought to find adequate expression in symbolism. In the author's desk is a special six-inch "Golden Rule" which embodies the heart of justice and fairness better than any other symbol created to this day. This symbol could be used on plaques and wooden shields, or in mosaic work.

5. The clasped hands, with pictures of a stole and the hand of God over them, as the symbol of marriage, or two doves symbolizing marital bliss, have not been widely used for some reason. If a new symbol were to take hold it would have to be even more dramatically connected with the marriage rituals or the obligations to be assumed.

6. The Church is waiting for the creation of vestments acceptable generally to Protestant clergymen.

Effective use of symbols as instruments of Christian education is illustrated by the medallions of the St. John's Evangelical and Reformed Church School at Lansdale, Pa. These medallions, executed in pure antique leaded glass, were conceived by Alfred N. Sayres, for some years pastor of the church and now Professor of Practical Theology in the Lancaster Seminary.

In the windows of each department of this church school there is a group of symbols suggesting ideas or ideals appropriate to the age of the

THE HOME THE PLAYGROUND

THE SCHOOL THE CHURCH

students. The significance of the symbol is vital rather than traditional. In the junior department, for instance, four symbols suggest the home, the school, the playground, and the church. For the junior high group, a radiant Greek cross surrounded by clouds typifies the four-fold life—physical, mental, social, and spiritual; and the fork in the road calls attention to the need for Christian choices.

The young people's room has four medallions: The Torch, referring to youth's relation to the past and its obligation to bear the light of truth through the current age to the coming age; The Dawn, referring to youth's relation to the future—the new day that young people may help to usher in; Liberty, proclaiming that the bonds of sin, evil habit, and external

THE FOUR-FOLD LIFE THE FORK IN THE ROAD

77 •

THE TORCH

THE DAWN

authority are broken by the power of a life of sacrificial service, symbolized by the illumined cross with a pair of upstretched hands from which a binding chain is falling; and Law, symbolized by the Mosaic tablets, representing the inner, moral law in obedience to which true freedom is realized.

Since there are no windows in the room where the men's class meets, a tile mosaic appears above the fireplace. In this mosaic the tools of the various occupations—plow, hammers, a coin, and a book, representing agriculture, industry, commerce, and education—suggest that every man's calling is holy. He should regard his calling as a means to establish brotherhood, which is symbolized by four pairs of clasped hands, red, yellow,

LIBERTY

LAW

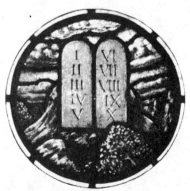

CHRISTIAN LIFE

black, and white. That brotherhood is God's purpose for mankind is suggested by a sunburst forming the center of the mosaic. On each side of the sunburst a heart with lilies growing from it stands for the beauty of divine love as it operates in a man's life for the realization of the brotherly ideal.

For the youngest children, there are two medallions, somewhat more traditional in character: The Lamb, representing the little child, and The Fold, suggesting the love and care of God. In the kindergarten department, symbols of Earth, Air, Sea, and Sky proclaim, "This is my Father's world: I rest me in the thought of rocks and trees, of skies and seas; his hand the wonders wrought."

THE LAMB THE FOLD

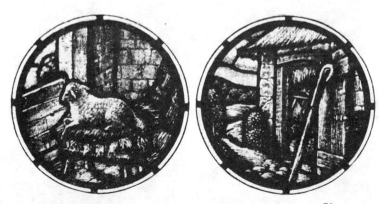

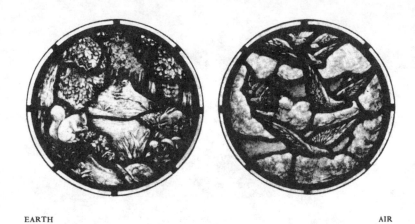

EARTH

AIR

THE KINDERGARTEN SYMBOLS

SEA

SKY

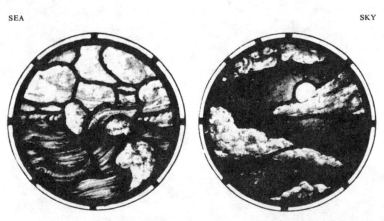

BIBLIOGRAPHY

Beaver, R. Pierce: *The House of God*. Eden Publishing House.

Benson, G. Willard: *The Cross—Its History and Symbolism*. Privately printed.

Fleming, Daniel Johnson: *Christian Symbols in a World Community*. Friendship Press.

Goldsmith, Elizabeth: *Life Symbols as Related to Sex Symbolism*. G. P. Putnam's Sons.

Goldsmith, Elizabeth: *Sacred Symbols in Art*. Ibid.

Griffith, Helen Stuart: *The Sign Language of Our Faith*. Morehouse-Gorham Co.

Leachman, Edgecombe W.: *The Church's Object Lessons*. Morehouse-Gorham Co.

Mackenzie, Donald A.: *The Migration of Symbols*. Alfred A. Knopf, Inc.

Seymour, William Hood: *The Cross in Tradition, History, and Art*. G. P. Putnam's Sons.

Stafford, Thomas Albert: *Christian Symbolism in the Evangelical Churches*. Abingdon-Cokesbury Press.

Strodach, Paul Zeller: *A Manual on Worship*. Muhlenberg Press.

Sullivan, John F.: *The Externals of the Catholic Church*. P. J. Kenedy & Sons.

Van Treek, and Croft, A.: *Symbols in the Church*. The Bruce Publishing Co.

Webber, F. R.: *Church Symbolism*. J. H. Jansen Co.

Whittick, Arnold: *Symbols for Designers*. C. Lockwood and Son, Ltd.

Wilson, Frank E.: *An Outline of Christian Symbolism*. Morehouse-Gorham Co.

INDEX

•

Folios in *italic* refer to illustrations